# YEOVIL

## THE POSTCARD COLLECTION

BOB OSBORN

AMBERLEY

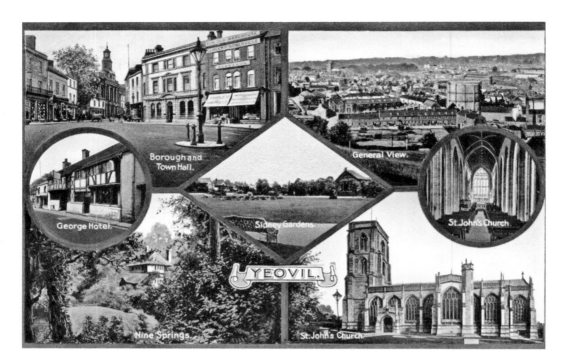

Yeovil multiview postcard, 1909.

*For Carolyn and Alice.*

First published 2019

Amberley Publishing
The Hill, Stroud, Gloucestershire, GL5 4EP
www.amberley-books.com

Copyright © Bob Osborn, 2019

ISBN  978 1 4456 7881 8 (print)
ISBN  978 1 4456 7882 5 (ebook)

British Library Cataloguing in Publication Data.
A catalogue record for this book is available from the
British Library.

Origination by Amberley Publishing.
Printed in Great Britain.

# CONTENTS

# INTRODUCTION

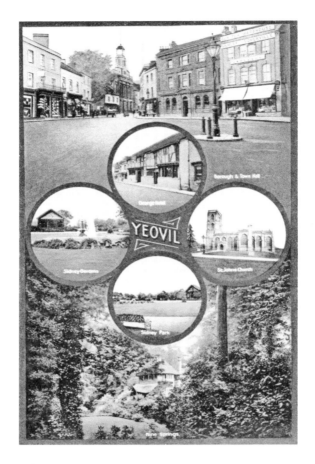

Yeovil multiview postcard, 1914.

## About Yeovil

Sadly there is very little evidence of life in the Yeovil area before the Romans, although some archaeological surveys have indicated signs of activity from the Paleolithic period, with burial and occupation sites located principally to the south of the modern town.

Immediately before the Roman invasion of Britain, the area that would become Yeovil was inhabited by the British Celtic Durotriges, a loose tribal confederation occupying a large area that included south Somerset.

The Westland Roman complex was a major discovery in 1916. Initially, the site was thought to be a villa, but more recent evidence shows that it may have been a small town

extending over 40 acres. After the Roman withdrawal from Britain, there is no evidence at all, physical or documentary, of any settlement in the Yeovil area for the next several centuries.

After the Norman Conquest in 1066, what would become Yeovil was divided into two manors: Hendford and Kingston. There were also twenty-two freeholdings, later known as 'The Tenement', which would eventually become the medieval manorial borough. At the time of the Domesday Book (1086), Yeovil was too small to be considered a town, it was not a borough by charter and didn't have a market.

By 1305 the 'Tenement' had become a free borough. With this came certain rights such as the right to elect burgesses. The original borough of Yeovil was a relatively tiny part of today's town and was centred on St John's Church, albeit not the present fabric.

Through the next centuries, the town grew little but prospered as the leather and gloving industries expanded. By 1840 there were thirty-six Yeovil glove manufacturers. Gloving slowly increased throughout the latter half of the nineteenth century, becoming the main focus of the town. After the Second World War, the gloving industry fell into decline, with the last glove factory closing in 1989.

In more recent times, with the growth of Yeovil's aircraft and defence industries, the town retains an important role in the local area and county.

## About Postcards

The world's oldest postal card was sent from London in 1840. The Post Office issued postal cards without images in Great Britain from 1870. These were printed with a stamp as part of the design, which was included in the price of purchase.

Photo postcards were first used in the UK from around 1898, although very few survive from that date. Originally, messages were not allowed to be written on the address side of the card. However, many people were unaware when this rule ceased in 1897. As a result, cards are occasionally found from the first decade of the twentieth century where a message has been written in minuscule writing on the photo side – there is an example in this book on page 24.

Around 1900 the carte de visite and the cabinet card, the most popular photographic formats of the late nineteenth century, were going out of fashion. The new postcard format filled a gap in the growing market and became the new cheap photograph format that could be posted to your family and friends. At the turn of the century, Yeovil was fortunate in having several postcard publishers: bookseller Ebenezer Whitby and printer William Beale Collins, both of Princes Street; the fancy goods dealers Ince Gamis of High Street and E. J. Bowditch of Middle Street; and newsagent H. T. Balls of Sherborne Road. This was at a time when you could send a postcard in the morning and it would often arrive at its destination in the afternoon. The period between the turn of the century and the start of the First World War became known as the 'Golden Age' of the postcard. Although I have over 850 postcards of Yeovil, sadly there is only one postcard of Yeovil available in the shops today.

It should be remembered while looking at the postcards in this book that before the 1960s coloured postcards were invariably monochrome photographs coloured by hand – with varying degrees of success and accuracy.

# CHAPTER 1
# ST JOHN'S AND OTHER YEOVIL CHURCHES

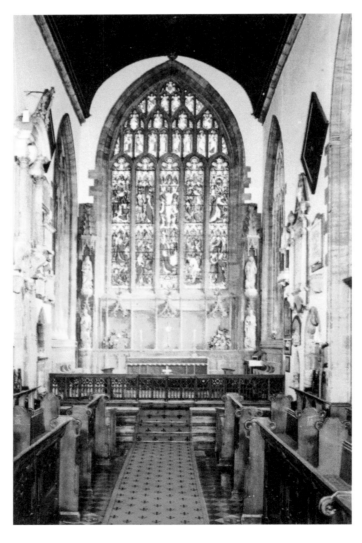

The nave of the Church of St John the Baptist.

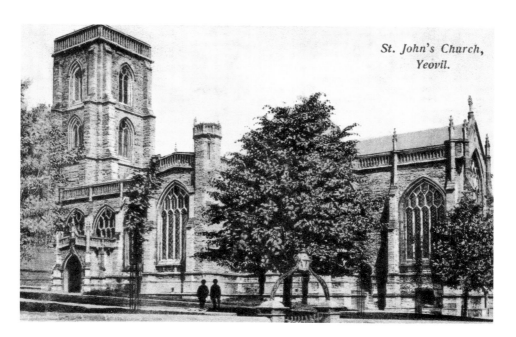

St John's Church

The earliest church on this site was recorded around 950, although this was most likely rebuilt by the Normans since it is recorded in 1226 as 'the great church of Gyvele'. Today's St John's Church, probably the third on this site, was completely rebuilt between 1380 and around 1400 under the auspices of Canon Robert de Sambourne. It was most likely designed by the master mason of Wells, William Wynford. The upper postcard was published by W. Hallett of Yeovil in 1903. Below, the postcard from Milton's Fac-Simile Sunset series is postmarked 1917 but the original photograph was taken several years earlier. This image was used for at least five different postcards. It should be noted that sunsets in the northern sky are not possible.

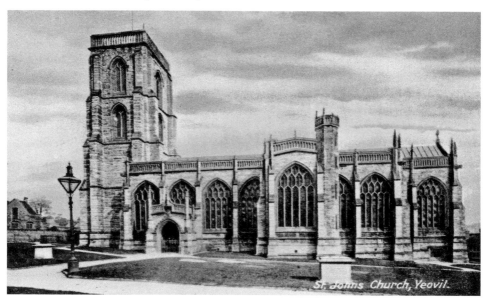

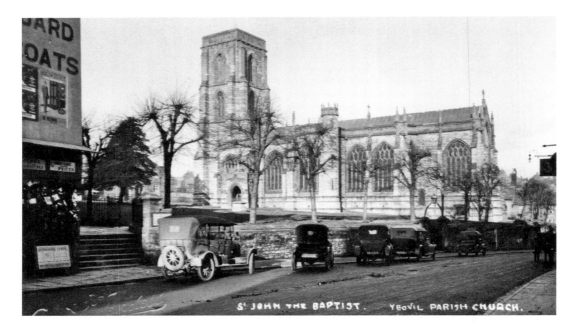

## St John's Church

St John's has long been known as the 'Lantern of the West' because of the superb windows that admit such a flood of light. The southern aspect of the church is the most photographed and includes the massive tower, the seven large and graceful traceried windows of the south aisle and transept as well as the lofty pinnacles and parapets. The upper postcard dates from the 1920s when the churchyard still had iron railings and gates to keep out dogs and horses. The railings were removed for the war effort in the 1940s. The aerial view below is one of a series of 1970s postcards.

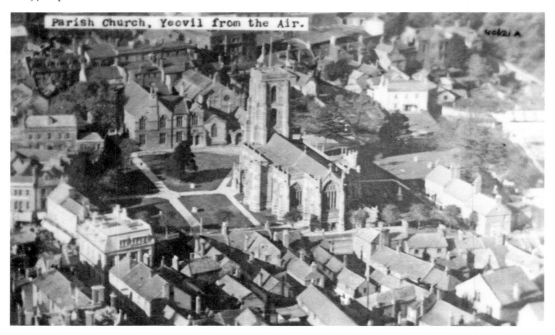

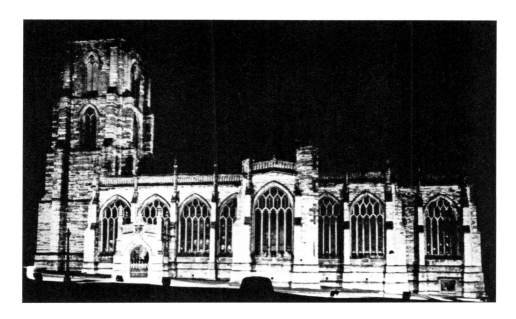

St John's Church

The unusual upper postcard was published in Yeovil by the photographers Rendell & Sons. The text on the reverse reads: 'Flood-lit on the occasion of the Silver Jubilee, 1935, by the Yeovil Electric Light & Power Company Limited'. The lower card is undated but is thought to date from the 1980s. St John's churchyard was largely cleared of headstones and tombs during the 1920s. Known locally as 'The Beach', the churchyard has been a popular spot to enjoy sitting in the sunshine since the end of the Second World War.

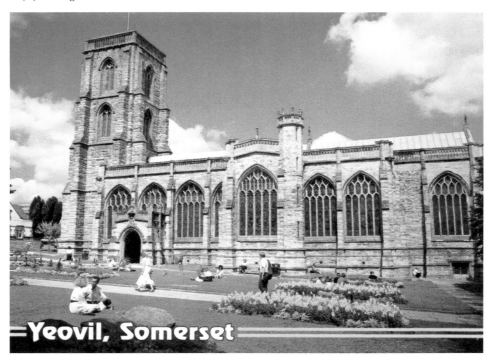

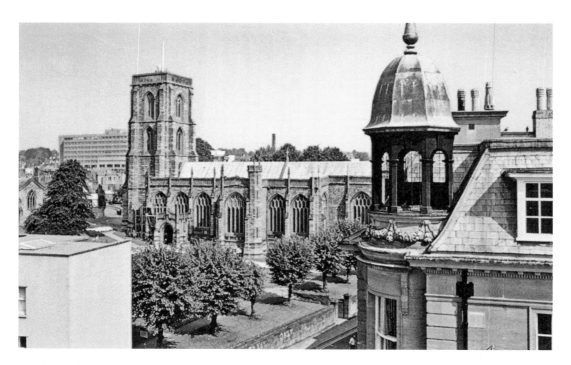

St John's Church

Both cards on this page are from the late 1970s Colourmaster International series by Photo Precision Ltd of Huntingdon. The upper postcard looks across the Borough to see the church in its wider setting and was taken from the roof of the Cadena Restaurant building (demolished in 1983) on the corner of Wine Street. The photograph of the lower postcard was taken from the roof of the HSBC bank building – seen at right in the top postcard. By the 1970s, as seen in this postcard, the churchyard was decorated with colourful flower beds.

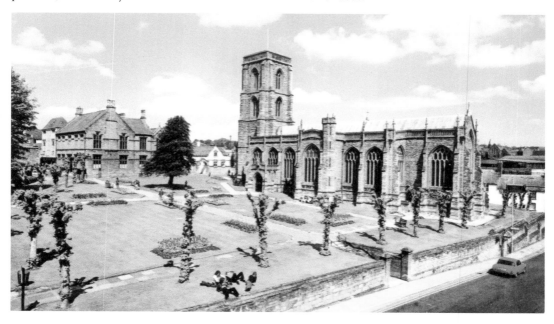

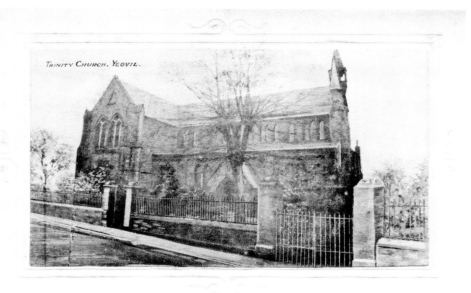

## Holy Trinity Church

The Church of the Holy Trinity in Peter Street was designed by the famous diocesan architect Benjamin Ferrey and built between 1843 and 1846. In the 1970s the interior was rearranged: the pulpit, pews and stalls were removed and a freestanding altar was placed within the eastern bay of the nave. Congregations declined, and in the 1980s plans were set in place to relocate the church to Lysander Road. The new church was completed in 1998. The upper embossed vignette postcard dates to around 1900 and was published by fancy goods dealer E. J. Bowditch of Middle Street. The lower postcard was published around 1905 by the printer and bookseller William Beale Collins of Princes Street.

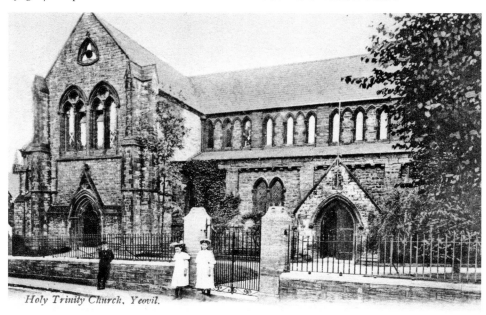

*Holy Trinity Church, Yeovil.*

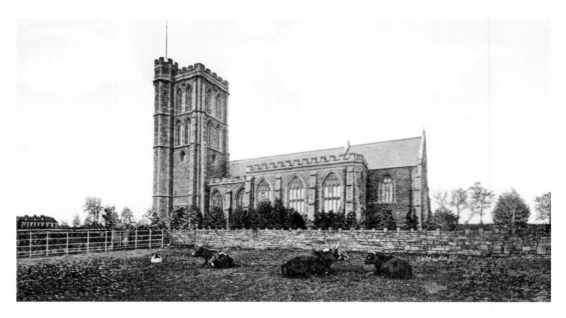

## St Michael's Church

Designed by Yeovil architect J. Nicholson Johnston in a uniform early fifteenth-century style with touches of art nouveau, St Michael and All Angels' Church opened in 1897. Largely paid for by the Cole family, it cost in the region of £10,000 and was intended to serve the new Pen Mill parish. The image of the upper postcard dates from this time since the houses in St Michael's Avenue do not appear in this image. This postcard, in several issues, was still in use in the mid-1920s. The lower image shows the vicarage, which was built concurrently with the church. This image dates after 1912 when the houses at extreme left were built.

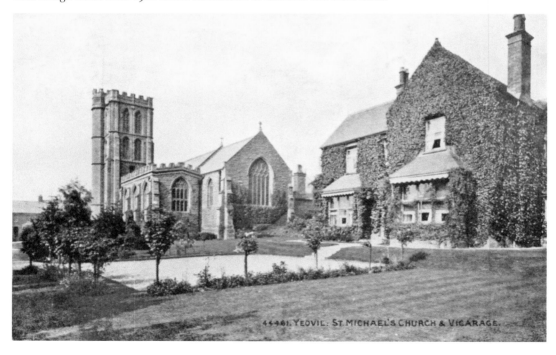

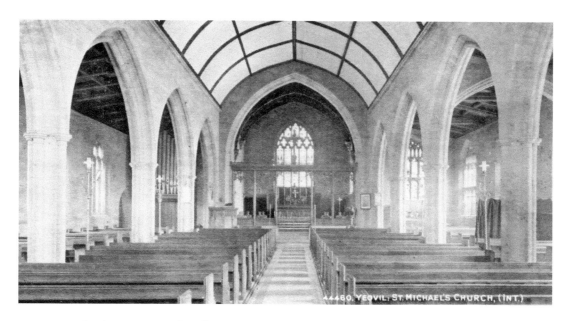

## St Michael's Interior and Hall

The early fifteenth-century architectural style, seen on the outside, is continued inside with the detailing of the aisle arcades, chancel arch and window tracery. Originally built with a large number of pinnacles surmounting the tower, a violent storm in 1896 blew two pinnacles down and the remainder were removed. St Michael's Hall, completed in 1908 and seen in the lower postcard, was built as a community hall to serve the St Michael's Road area. Its main claim to fame is that during the Second World War it was the only available structure in Yeovil large enough for a barrage balloon to be fully inflated inside it in order for repairs to be undertaken.

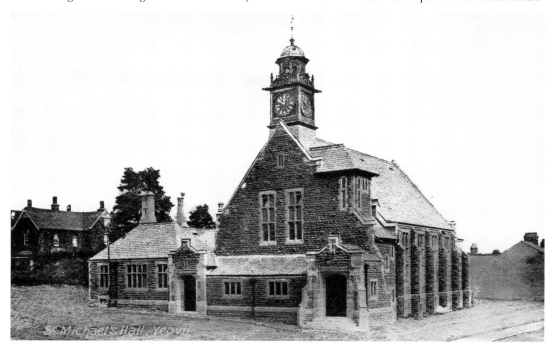

## Church of the Holy Ghost

In 1896 Revd A. J. C. Scoles, an architect and the parish priest, built a new Roman Catholic church and presbytery. The Church of the Holy Ghost was built in the Early English style between 1894 and 1899. The church has a five-bay nave with a polygonal apse, a three-bay Lady chapel and a vestry on the north. The upper postcard dates to 1904. The lower postcard features the presbytery alongside the church. This is one of a 1920s series of postcards of the church by specialist ecclesiastical photographers Lofthouse, Crosbie & Co. of London.

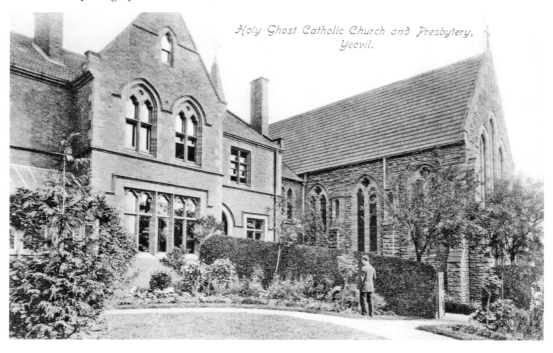

Holy Ghost Catholic Church and Presbytery, Yeovil.

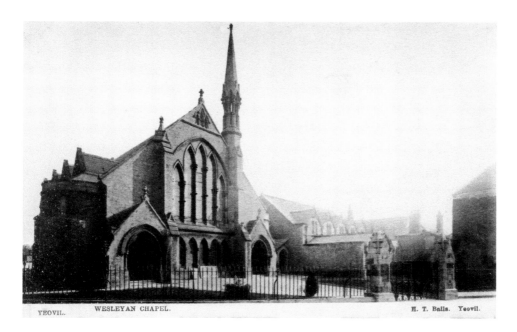

YEOVIL.    WESLEYAN CHAPEL.                                    H. T. Balls.    Yeovil.

## Methodist Church and Christ Church

In 1869–70 the new Wesleyan Methodist church (above) was built in Vicarage Street. This subtly coloured postcard, by H. T. Balls of Yeovil, dates to 1906. The church was damaged, including losing its spire, during the first Luftwaffe raid on Yeovil in October 1940. Today the church has an active congregation and is part of the Yeovil and Blackmore Vale Methodist Circuit. The Reformed Episcopalian Christ Church, below, was built in the Early English Revival style in Park Road. It opened in 1880 but the congregation dwindled dramatically and in 1904 it was demolished – lasting just twenty-five years. The photograph was taken in 1880 but the postcard was used in 1903.

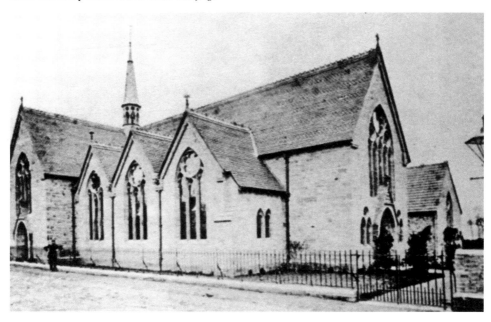

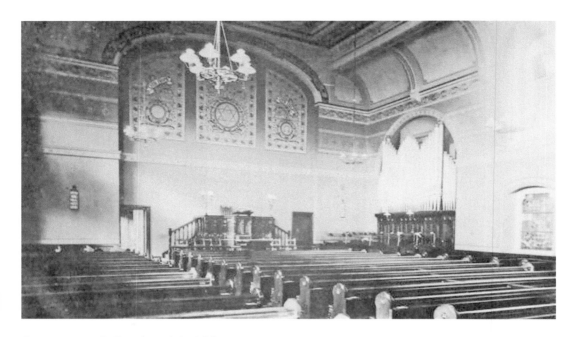

## Congregational Church and St Gildas' Convent

The first Congregational church built on this Princes Street site was erected in 1791, with an entrance onto Clarence Street. In 1877 the present church was designed in the Lombardic style of architecture by T. Lewis Banks of London and built by Frederick Cox of Yeovil. The 1930s postcard shows the interior of the church. It became the United Reformed Church in 1972 but closed during the summer of 2017. In 1903 a house was acquired by the Sisters of St Gildas-des-Bois, who originated in Brittany, France. They built the St Gildas' Convent on the site between 1912 and 1928 (seen below). The convent closed and was demolished in 1984. This postcard dates to 1935.

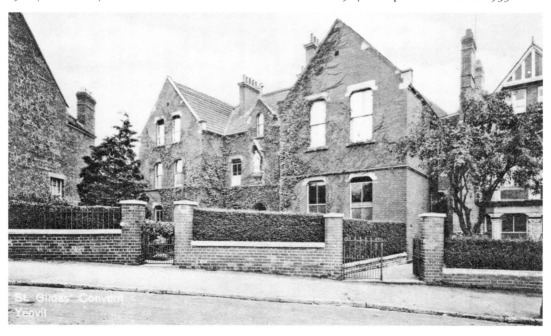

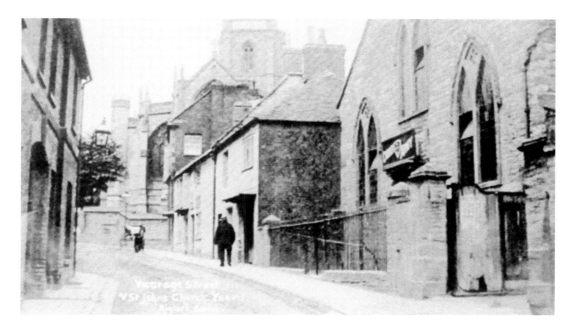

## Unitarian Chapel and Baptist Church

The Unitarian chapel in Vicarage Street was built on the site of the medieval Chantry of the Blessed Virgin Mary. The chapel was founded in 1704 but rebuilt in 1809 and this is the building seen in the upper postcard, of around 1910. The chapel was demolished in the early 1980s for the construction of the Quedam shopping precinct. The Baptist church in South Street (seen below) was built on the site of a barn first used for meetings from 1668. A chapel was built in 1810 and replaced in 1828. It was enlarged in 1868 and a choir added in 1898. This postcard dates to 1912.

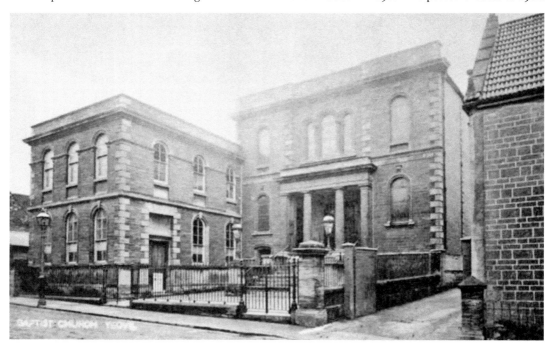

# CHAPTER 2
# HIGH STREET AND THE BOROUGH

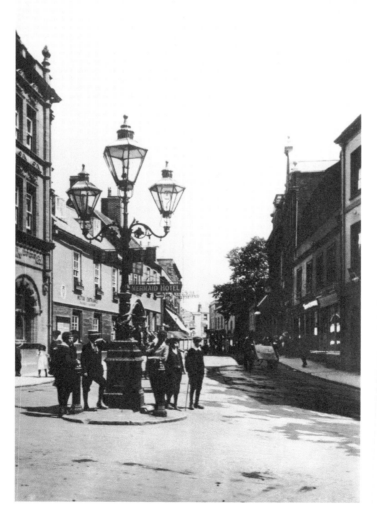

A 1905 postcard of High Street, photographed from Hendford.

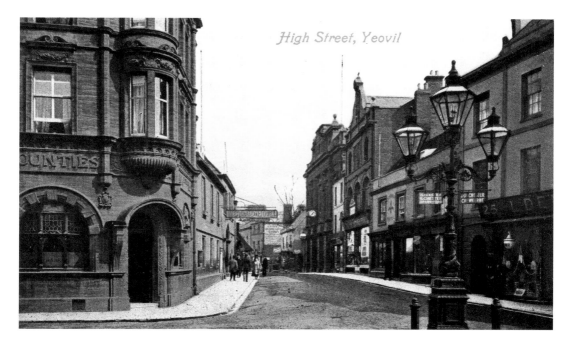

High Street

The upper postcard on this page dates to 1909 and shows High Street seen from Hendford. It features the Capital & Counties Bank (opened in 1897) at left, on the corner with Princes Street. At centre right is seen the Town Hall built in 1849. A short clock tower was added to the Town Hall in 1864 but removed in 1887 because it became unsafe. The lower card, from 1903, looks to High Street from the Borough (technically still part of High Street). At centre is the Town Hall and the large tree is now the location of King George Street.

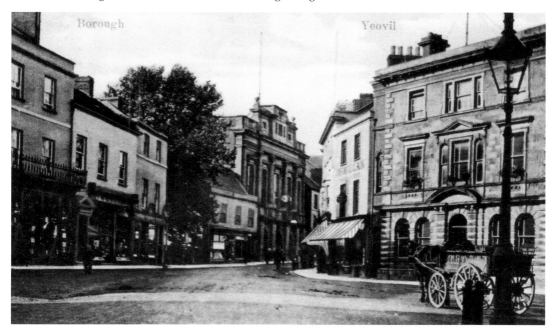

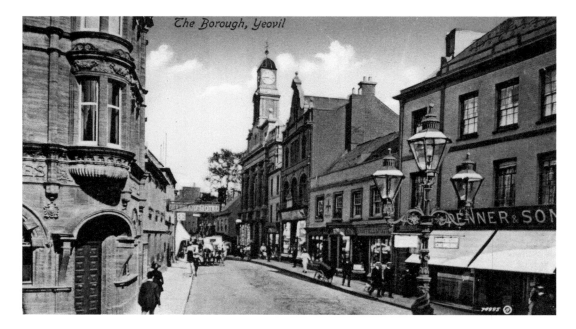

*The Borough, Yeovil*

## High Street

The two postcards on this page (1927 above, 1918 below) almost mirror the postcards of the previous page – the chief difference is the Town Hall. Having removed the structurally unsafe clock tower in 1887, it was replaced in 1912 with a new, tall and somewhat grandiose steel structure as seen in these postcards. The new four-face clock was illuminated at night by gas jets. Unfortunately, the Town Hall was completely destroyed by fire in 1935 when, it is believed, waste paper blew into the clock tower and was ignited by the gas jets. Both these postcards were issued in at least four different versions.

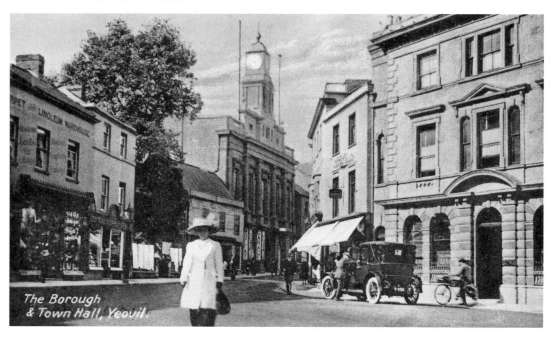

*The Borough & Town Hall, Yeovil.*

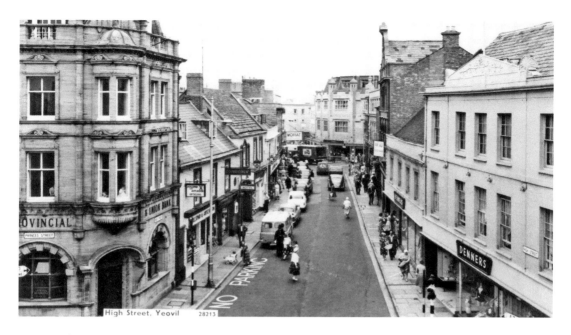

## High Street

Again, almost mirroring the postcards of the previous two pages, these two postcards are from 1954 (above) and 1944 (below) – after the demise of the Town Hall in 1935. The upper image is almost identical to today's streetscape except that the two-storey part of Denner's department store at right is now four storeys like the rest of the store. At the centre of the lower image are the municipal offices (opened in 1928) built on the west side of King George Street. To the left is another of Yeovil's earlier department stores, Frederick Taylor's (later Plummer-Roddis). Opened in 1926 as a two-storey building, by the time of this postcard a third floor had been added.

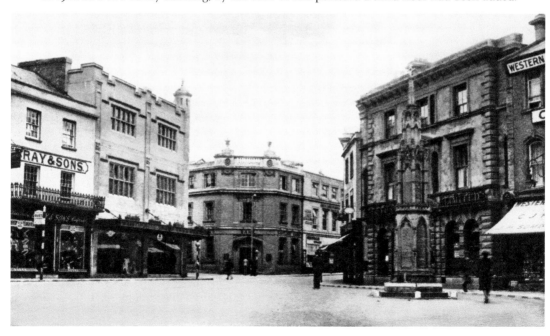

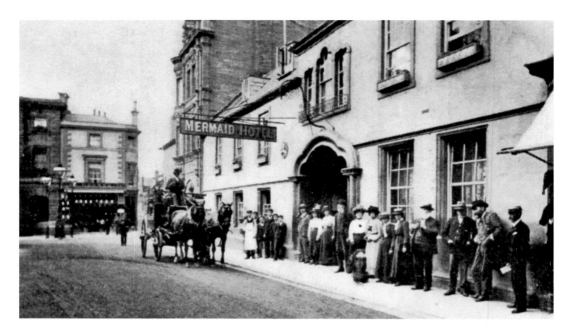

## The Mermaid and High Street

The upper postcard dates to 1910 and shows the Mermaid Hotel in High Street. The Mermaid is the oldest surviving licensed premises in Yeovil, with the earliest mention in the records being 1517. The Mermaid had its own horse-drawn omnibus (seen here) that ran to and from the railway stations as a courtesy to guests. Note in the background the edge of Stuckey's Bank and Denner's outfitters in Hendford that were both demolished so that Westminster Street and the Westminster Bank could be built. The lower postcard, dated 1907, shows High Street as seen from the first floor of the Stuckey's Bank building.

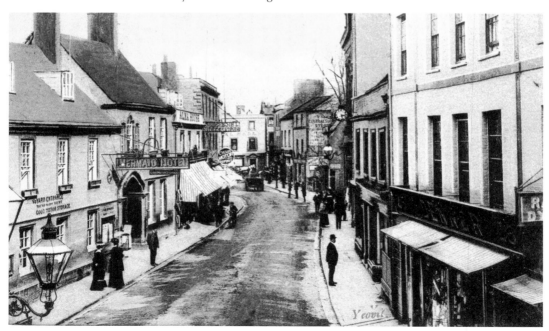

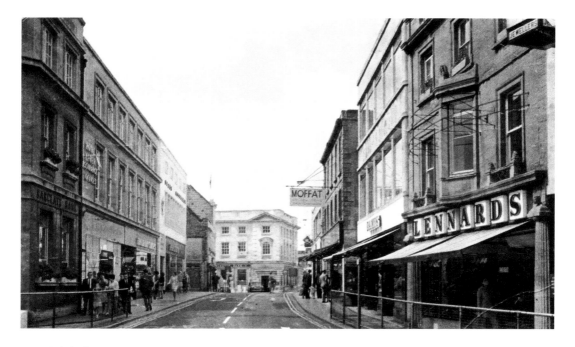

## High Street

The upper postcard on this page dates from 1970 and looks west along High Street from the junction with King George Street. Note in the background the Westminster Bank building that replaced Stuckey's Bank. All the buildings in this postcard remain today. The lower postcard is taken from High Street, looking towards the Borough, and dates to 1960. Plummer's (formerly Frederick Taylor's) department store, which started life as two storeys high, subsequently had a third storey added and finally the fourth storey as seen here. In the centre, with the flag, is the Boots building in the Borough, which was rebuilt after being destroyed during the war.

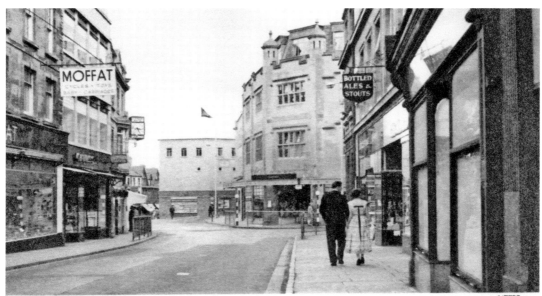

YEOVIL, THE HIGH STREET                                                    V7782

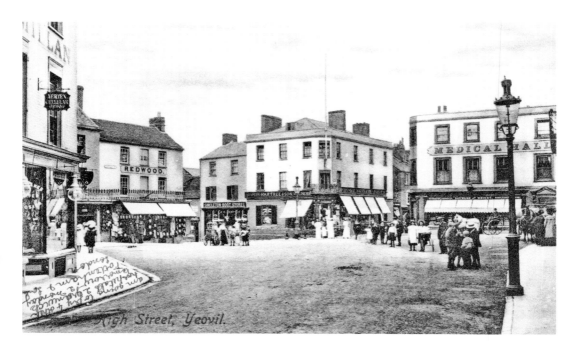

## The Borough

The upper card on this page, by Whitby & Son of Yeovil, dates to 1904. In the centre is London House (built in 1836 and demolished in 1913) with Silver Street to its left and Middle Street to the right. On the other corner of Middle Street is the Medical Hall, which was used by chemist and apothecaries throughout its existence. Note, in the lower left corner, the message from the sender who clearly did not realise that the rule forbidding a message on the address side of the card had been rescinded. The lower postcard of around 1950 looks east across the Borough. Note that it was still possible to drive behind the war memorial.

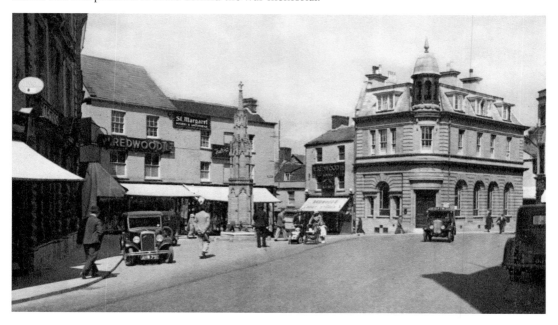

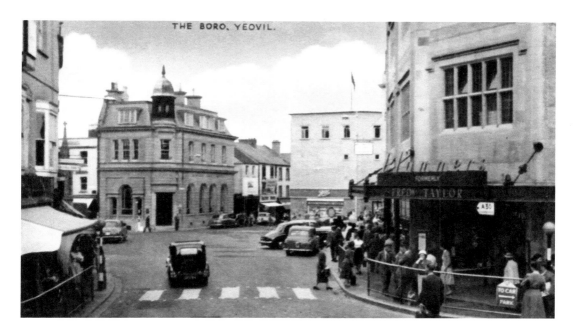

The Borough

The upper postcard on this page (from Dennis & Son's Photoblue series) corresponds to the upper postcard on the previous page but dates to the late 1950s. London House, seen in the opposite card, has been replaced by the new bank building and the Medical Hall, bombed during the war, was rebuilt in the mid-1950s by Boots the Chemist, who owned it at the time. The lower postcard on this page similarly corresponds to the lower card on the previous page, but dates to 1972. All the buildings in both postcards remain today, albeit many with new occupiers.

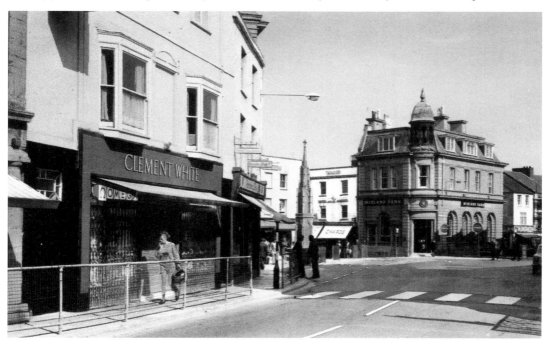

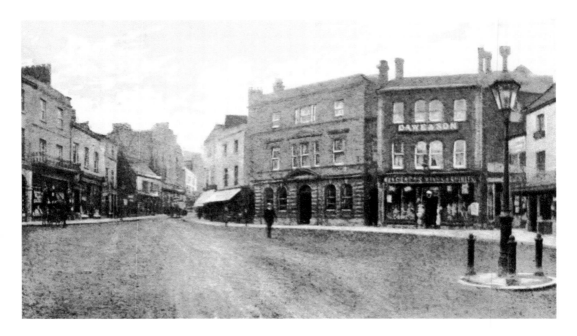

## The Borough

Both postcards on this page show the clear space in the Borough before the war memorial was built. The upper postcard, of 1909, shows the Borough looking west towards High Street. The building in the centre, Lloyds Bank, was built in the 1850s. It was completely rebuilt, except for the front elevation, during the 1980s. The building to the right, at this time the premises of Dawe & Son, was known as the Gun Tea Warehouse. It was later owned by Shirley and Somerville, as seen in the lower postcard, which dates to around 1915. All buildings in both cards survive today except those on the left of the upper postcard.

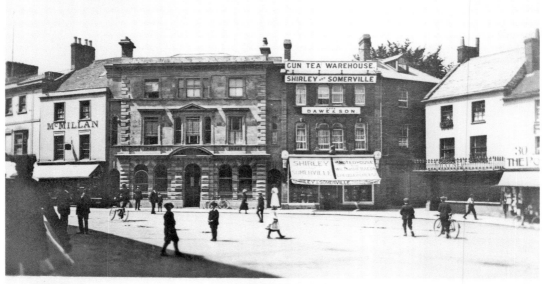

S.9477.                                        THE BOROUGH. YEOVIL.

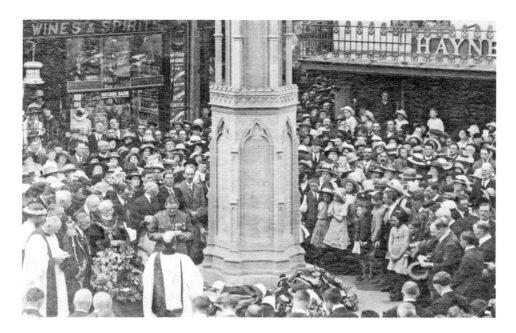

## The Borough and the War Memorial

A memorial to honour Yeovil's war dead was first proposed at a meeting of the borough council in July 1917 by Mayor Edmund Damon. The upper postcard shows the unveiling of Yeovil's war memorial in the Borough, at a ceremony that took place at 6 p.m. on Thursday 14 July 1921. The 29-feet-high memorial was designed by Charles Wilfred Childs and sculpted in stone by Messrs Appleby and Childs of Yeovil. The style of the memorial was based on the Eleanor Crosses erected by Edward I in memory of his wife, Eleanor of Castile, in 1290. The lower postcard dates to 1930, before the Town Hall, seen in the background, burnt down.

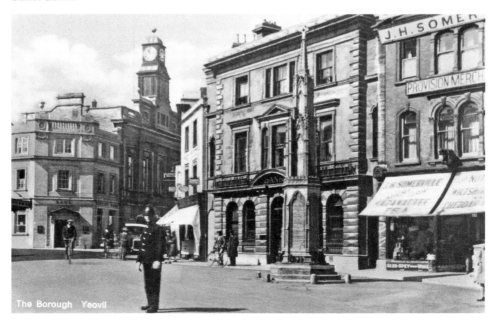

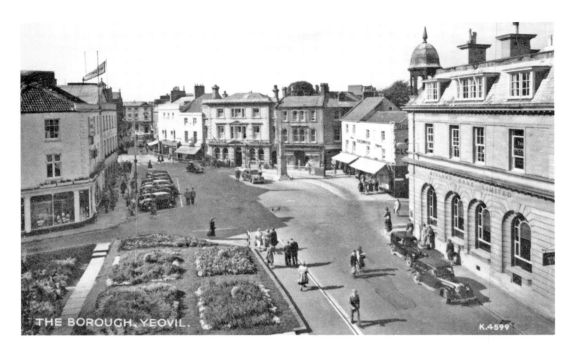

The Borough Garden and Boro' Clothing Hall

The Medical Hall, seen in earlier postcards in this book, was destroyed by German bombing on Good Friday 11 April 1941. Immediately after the war, the site was cleared and an ornamental garden laid out, planted with tulips donated by Dutch children who had been evacuated to Yeovil during the war. Boots the Chemist, who owned the building, rebuilt it during the early 1950s. The lower postcard, from the early 1950s, shows Redwood's 'Boro' Clothing Hall' in front of St John's Church. It was proposed in the 1850s (and several times since) that these buildings should be demolished in order to open the view to the church. The discussion still continues today on social media.

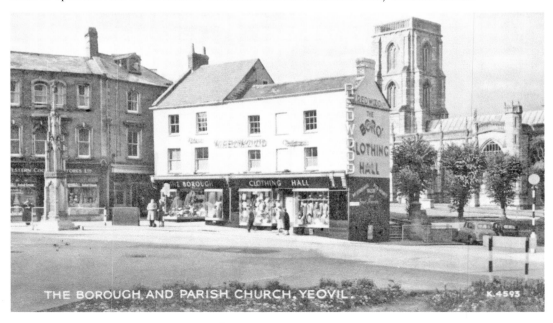

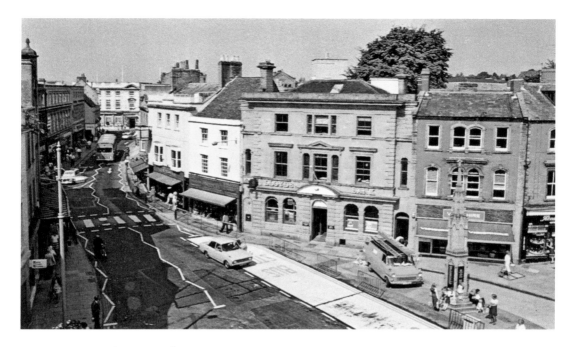

Bus Stops, the Borough

Both postcards on this page date to the 1970s. Far from the wide open space of earlier times, the Borough, thanks to a great increase in vehicular activity, was gradually being reduced to a road-width plus a pedestrianised area and bus stops by the war memorial. The upper card, taken from the roof of the present Burger King building, shows temporary barriers between the road and the war memorial. It was, however, still possible to drive behind the memorial. The lower postcard shows the railings that were installed in the late 1970s to protect people waiting for buses. Note to the far left, the municipal offices that opened in 1928.

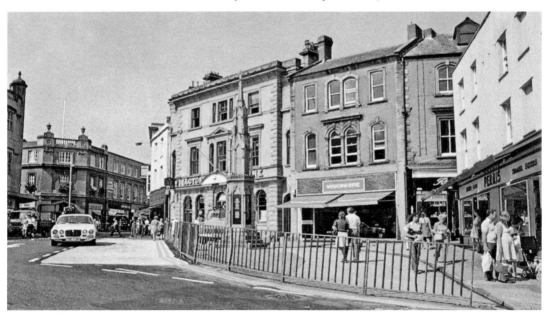

# CHAPTER 3
# MIDDLE STREET AND THE TRIANGLE

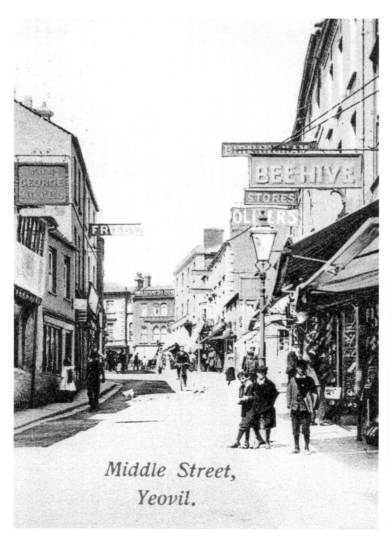

Middle Street, looking back to the Borough in 1905.

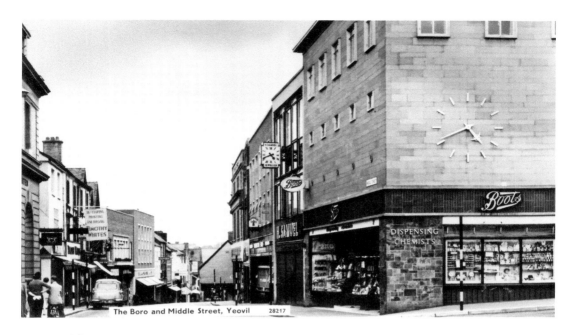

The Boro and Middle Street, Yeovil    28217

## Middle Street

The upper postcard on this page, of 1963, shows Middle Street as seen from the Borough and features the new Boots the Chemist's building (now Burger King) to the right. This building opened in 1956 and replaced the former Medical Hall. In the distance, in the centre, is seen the George Inn and other buildings that projected into Middle Street. The lower postcard dates to 1940 and looks back along Middle Street towards the Borough, from the junction with Union Street. The buildings jutting out into Middle Street (with the Dyer's sign) would also be destroyed by the bomb that destroyed the Medical Hall.

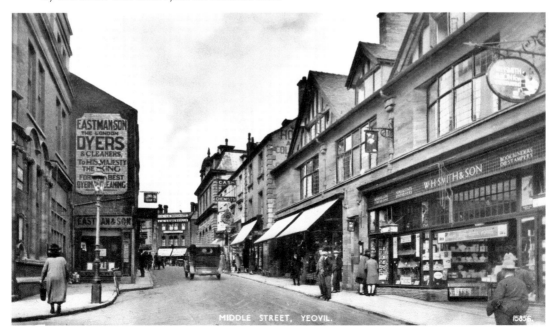

MIDDLE STREET, YEOVIL.    15856.

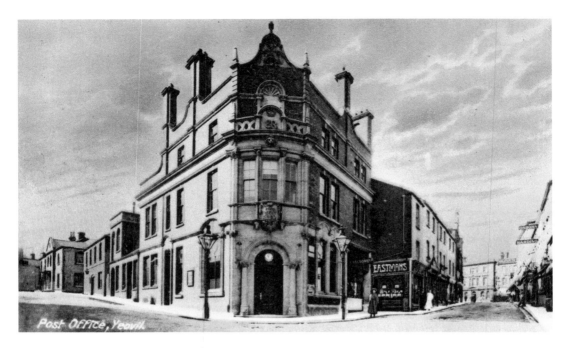

## Post Office and Middle Street

The upper postcard, from Milton's Fac-Simile Sunset series, was sent in 1903. This was the year after the new purpose-built post office (now the WHSmith premises) opened on the corner of Middle Street and Union Street. It remained Yeovil's main post office until 1932 when the new post office in King George Street opened. The lower postcard, of 1955, looks east along Middle Street. By this time the old post office building was occupied by Marks & Spencer. In the centre, the old buildings projecting into Middle Street (Chubb's bakery and the George Hotel) give a good impression of how narrow the road was at this point.

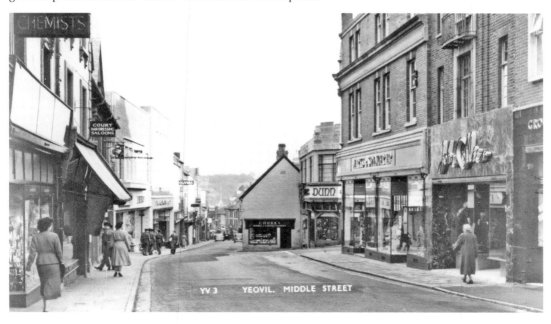

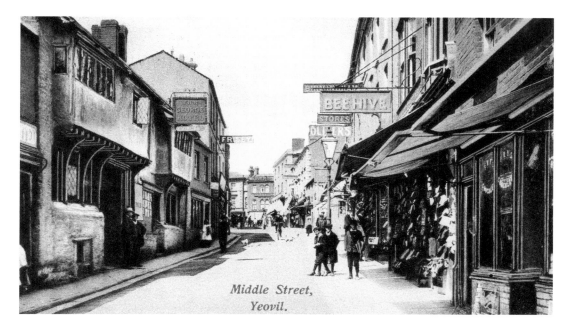

Middle Street,
Yeovil.

## The George Hotel and Middle Street

The George Hotel, featured in both these postcards, began life as a private dwelling built during the 1400s. The upper hand-tinted 1902 postcard is of Middle Street and looks west back towards the Borough, with the George Hotel to the left. At this time the black-and-white timberwork of the George was plastered over. The very unusual lower postcard, of 1903, was originally a normal daytime photograph but hand-coloured to represent a night scene. It looks east along Middle Street from roughly the same position. The George Hotel was demolished in 1962 for road widening against public outcry. This section of Middle Street was pedestrianised within ten years.

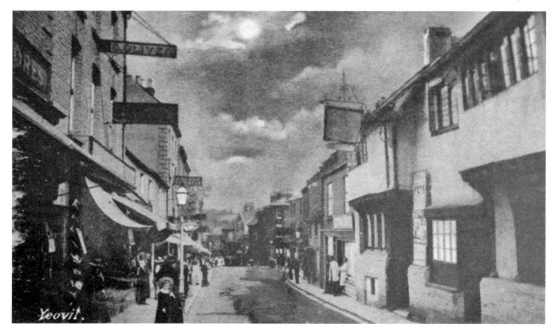

Yeovil.

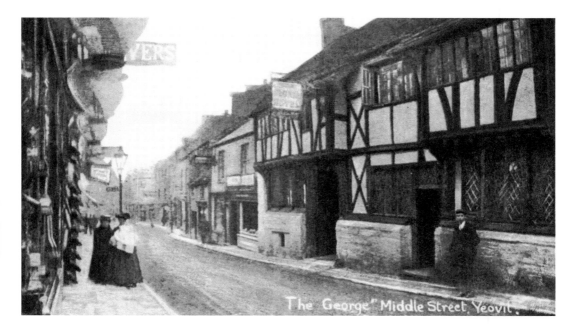

The George" Middle Street, Yeovil.

## Middle Street from the George Hotel

The upper postcard dates to 1910, by which time the structural timberwork of the George Hotel had been exposed. The lower postcard is a similar view taken some fifty years later. From 1478, the George was owned (among other licensed premises) by the trustees of Woborn Almshouse, who continued to hold it until 1920, with the rent of the building providing a regular income for the Almshouse. The building became an inn called the Three Cups (three cups being the arms of the Worshipful Company of Salters) in 1642. The Three Cups was renamed the George Inn during the early nineteenth century.

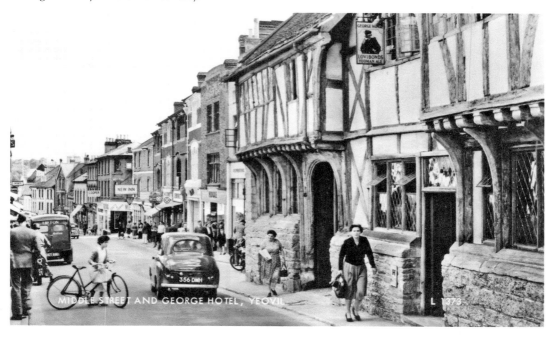

MIDDLE STREET AND GEORGE HOTEL, YEOVIL

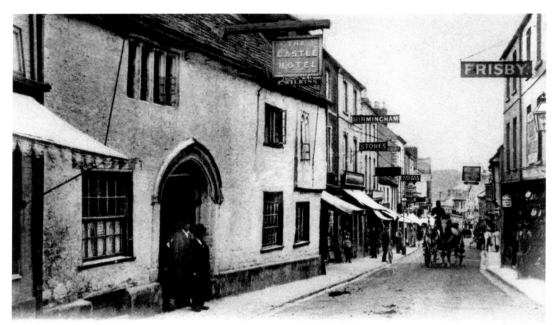

*Yeovil.*  Publ. by R. Wilkinson & Cᵒ, Trowbridge.

## The Castle Inn and Middle Street

Before its demolition in 1927 for street widening and the building of a new 'picture palace' on the site, the Castle Inn featured here was Yeovil's earliest house. It was, in part, thirteenth century and had been an old medieval chantry property. It opened as licensed premises before 1668 and was called the White Hart. Later it was known as the Higher Three Cups to distinguish it from another old medieval inn called the Three Cups, which was itself later renamed as the George, seen on the opposite page. The lower postcard dates to 1950 and looks back towards the Borough from slightly further down Middle Street.

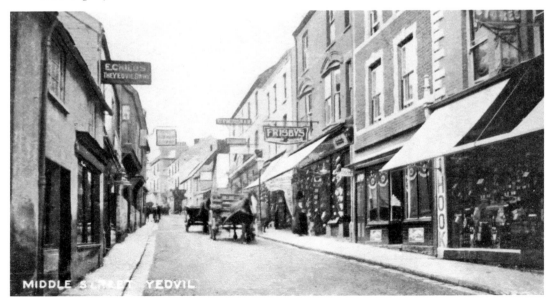

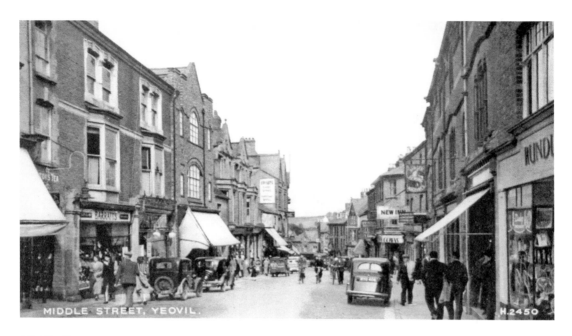

## Middle Street

The upper postcard on this page dates to 1943, by which time cars had long replaced the horse-drawn vehicle. The view looks east along Middle Street close to its junction with the Triangle. Cards of this period, as this one, frequently featured encouraging wartime messages from the prime minister on the address side; in this instance: 'We shall continue steadfast in faith and duty till our task is done.' The lower postcard is from the 1950s, and taken roughly from the same position as the above card but looking west towards the Borough. This was a time when most shops, as here, used blinds. It is a Dennis & Son's Photoblue series postcard.

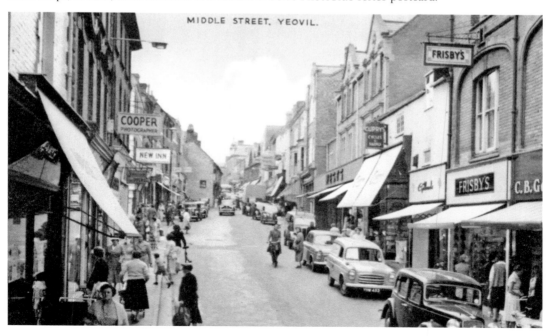

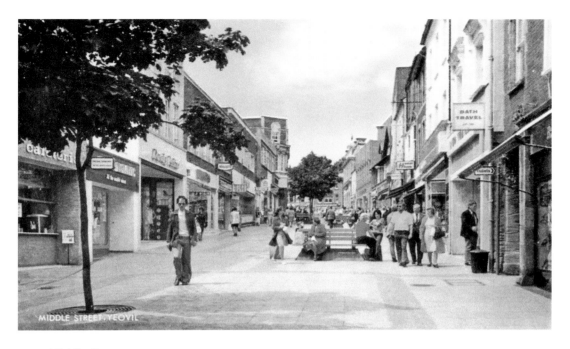

## Middle Street

Both postcards on this page feature the recently pedestrianised Middle Street, which was considered very 'modern' at the time. The upper postcard, looking towards the Borough, dates to the early 1970s. To the right is the entrance to Frederick Place, which features in the lower postcard between the Bellman's and Barratt's premises. The Barratt's building had once been the Albany Temperance Hotel, the front of which collapsed in 1879 when workmen digging a trench undermined its foundations. This postcard was sent in 1967. Mostly with new traders, all the buildings in these two postcards remain today.

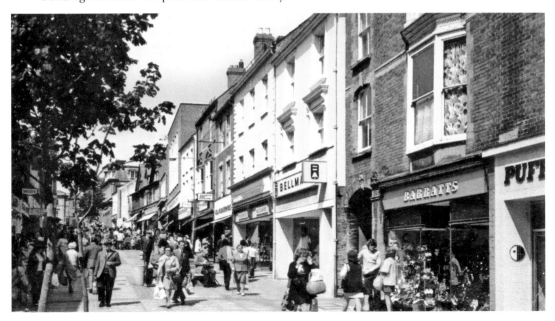

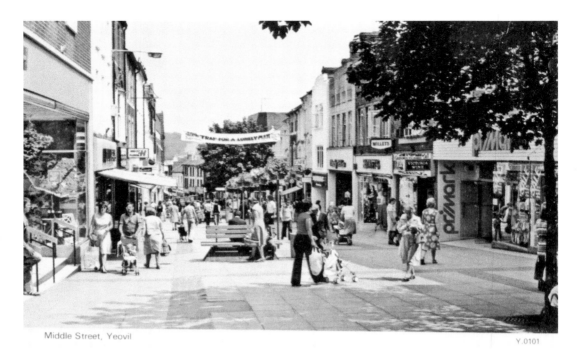

Middle Street, Yeovil

Y.0101

## Middle Street

Again, both the cards on this page were meant to display the newly pedestrianised Middle Street and promote Yeovil as a modern shopping centre. The upper postcard on this page dates to 1979, which was the year 'Trap for a Lonely Man' was performed at the Swan Theatre, which is advertised on the banner across the street. Some of these shops will be familiar, as well as those in the lower postcard of the 1980s, which looks back to the Borough. Again, all the buildings remain; it's just the shop occupiers that have changed.

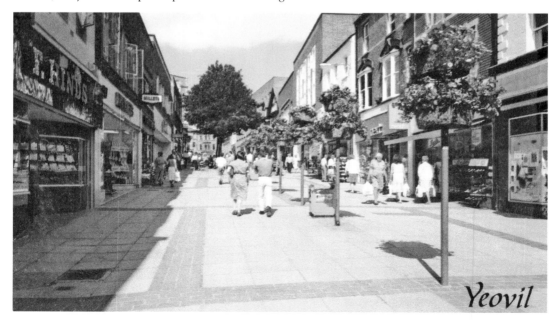

Yeovil

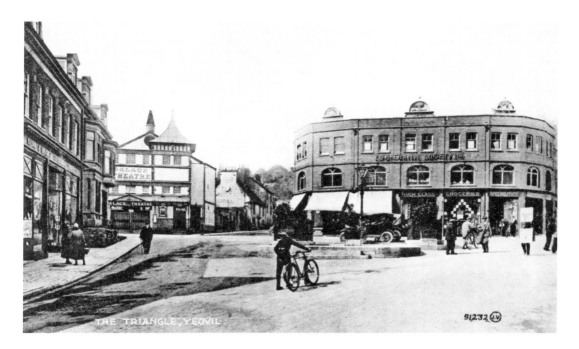

## The Triangle

The area known today as the Triangle is where Middle Street, South Street, Vicarage Street, Stars Lane and Fore Street (Lower Middle Street) met and in earlier times was the easternmost point of the Borough of Yeovil. The upper postcard of 1925 shows the infamous underground toilets in front of the Co-operative Society building with the Palace Theatre, on the corner of Stars Lane and South Street, to the left. The lower postcard dates to 1913 with the view shifted slightly right from that above. It shows the end of Middle Street to the left and Vicarage Street to the right and the Coronation Hotel and Vaults to the extreme right.

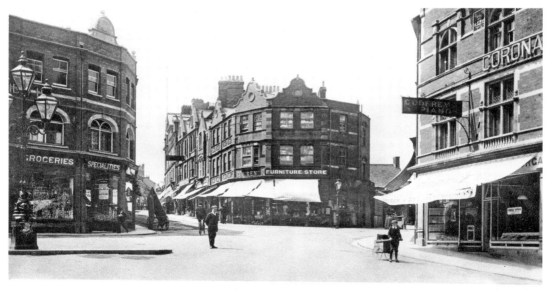

S 9481                    THE TRIANGLE, YEOVIL.

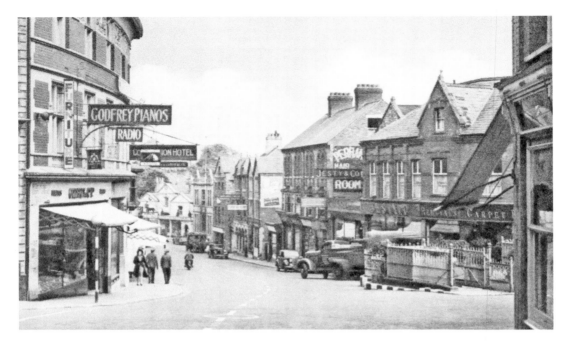

## The Triangle and Lower Middle Street

The upper postcard on this page dates to the 1940s (with another encouraging wartime message from Winston Churchill on the address side). The view looks down Lower Middle Street with the infamously malodorous underground toilets to the right and the Coronation Hotel and Vaults, housing Godfrey's piano shop in one corner, just glimpsed to the left. The lower postcard, of 1910, shows Lower Middle Street as seen from the Triangle. The impressive Coronation Hotel and Vaults was built around 1900 but was demolished in the 1960s, together with all the buildings beyond it, for the building of the new Glovers Walk shopping precinct.

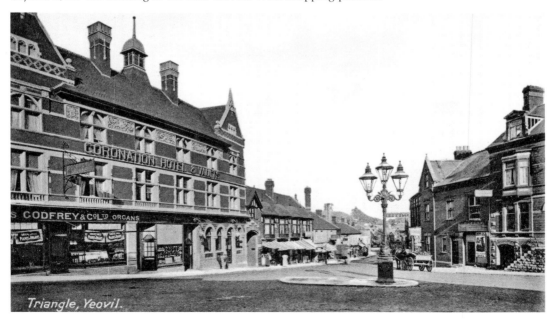

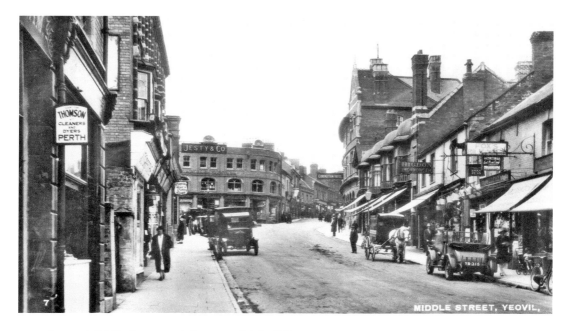

## Lower Middle Street and Commercial Buildings

The two postcards on this page (1923 above, 1912 below) are both taken from Lower Middle Street looking back towards the Triangle. As seen in the top postcard, this was in an age when the horse-drawn vehicle competed with the motor vehicle. The lower postcard, taken from slightly further east, features the row of shops with accommodation over known as Commercial Buildings, which was purpose-built as shop premises with living accommodation over in the 1870s. All the buildings to the right of both postcards disappeared in the 1960s when the Glovers Walk shopping precinct was built.

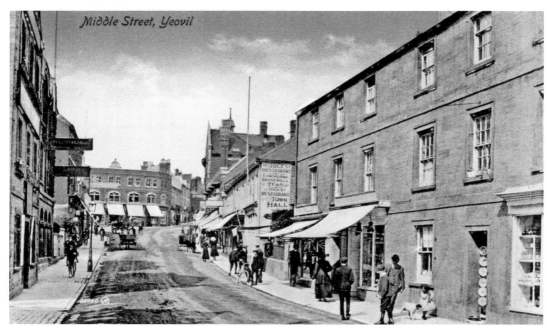

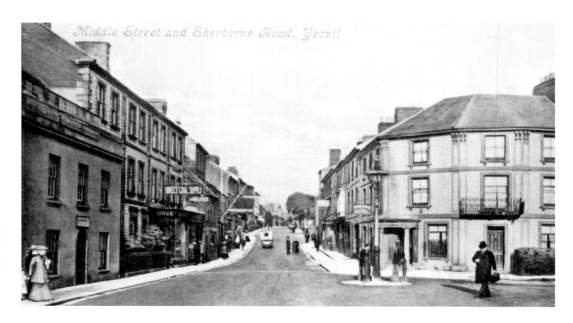

## Fernleigh Temperance Hotel and the *Western Gazette* Offices

The top postcard shows the eastern end of Lower Middle Street and, to the right, the entrance to Station Road. This postcard appeared in several forms – monochrome and at least three different hand-coloured versions. This example was used in 1907 and features the Railway Inn (demolished in 1913 and now the site of Central Road) to the extreme left and the Fernleigh Temperance Hotel (now a restaurant) to the right. The lower postcard, of 1906, features the newly opened *Western Gazette* offices that were officially opened in that year. The construction company was Bird & Pippard, builders and undertakers of Middle Street. The new building was constructed using 600,000 bricks on a steel-girder framework.

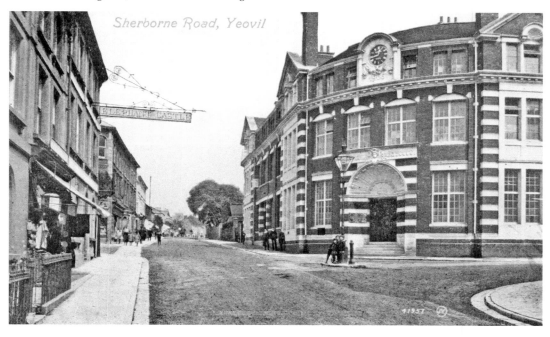

# CHAPTER 4
# HENDFORD HILL TO FIVEWAYS

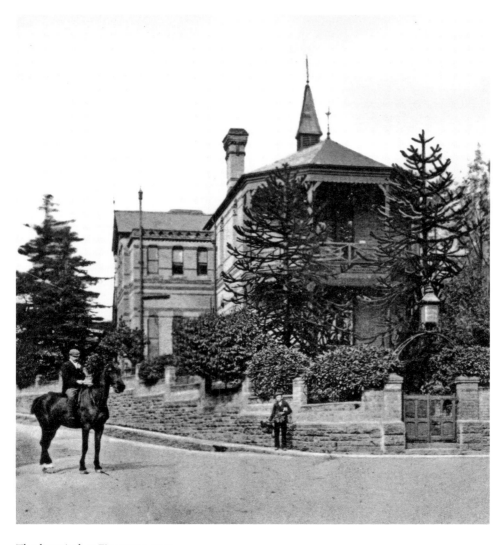

The hospital at Fiveways, 1911.

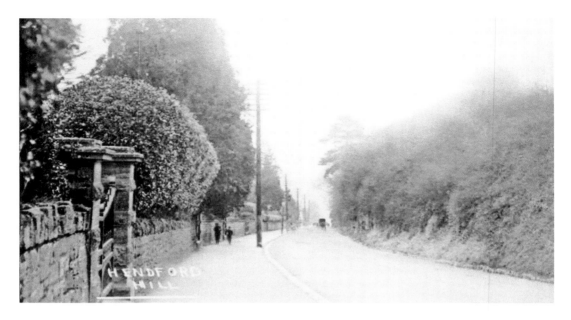

## Hendford Hill

Throughout the latter half of the nineteenth century, and into the twentieth, the road levels of Hendford Hill were changed, resulting in the high bank seen to the right in both of these postcards (1910 above, 1911 below). Another noticeable feature of the road realignment was that the Quicksilver Mail pub, at the top Hendford Hill, suddenly appeared to be two storeys high rather than its original three storeys. The only difference between this postcard and today is that the wide footpath was greatly reduced to allow the road to be widened. The lower postcard, a vignette set on a decorative and coloured mount, was a highly fashionable style at this time.

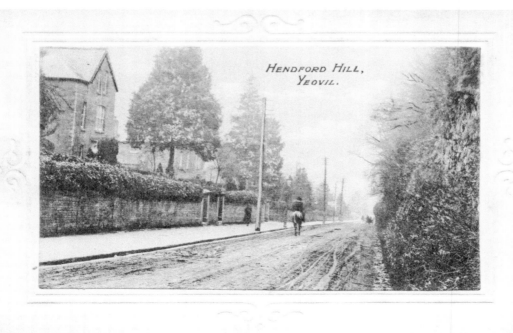

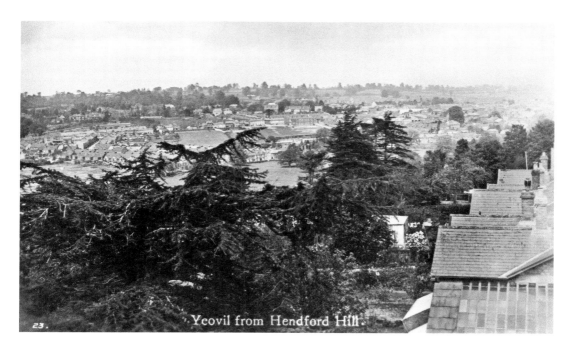

Yeovil from Hendford Hill.

## Hendford Hill

The upper postcard on this page dates to 1934 and looks north from the top Hendford Hill. The view looks across to Huish but also shows in the distance just how many fields, later to be covered by housing, existed at this time. The lower postcard dates to 1905 and looks up Hendford Hill from a position close to Rustywell. The houses to the right were built during the mid-Victorian period. To the left of the image, today's houses are yet to be constructed on land that had, during Victorian times, been a tree nursery.

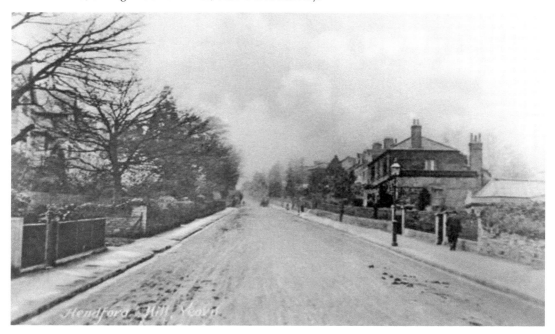

Hendford Hill, Yeovil.

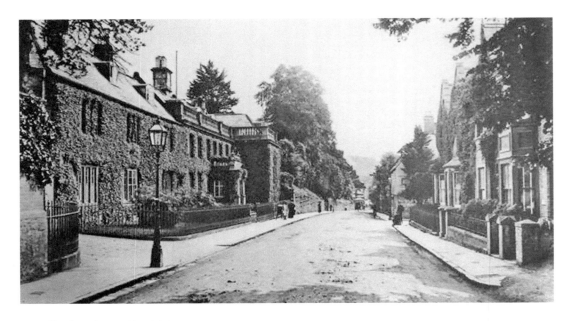

## Hendford and Hendford Manor

Moving now from Hendford Hill to Hendford itself, these two postcards look south (upper, 1912) and north (lower, 1905) from outside Hendford Manor. Hendford Manor was originally built around 1740 for Revd James Hooper, a Yeovil solicitor. It was one of the properties attacked and damaged by the mob of hundreds of protesters in the Yeovil Reform Riot of Friday 21 October 1831. Large extensions were added in the 1850s when attorney Edwin Newman occupied the house with his wife and eleven children. After the Second World War, the building was allowed to fall into disrepair to the extent that the interior had to be completely demolished, and today only the exterior walls are original.

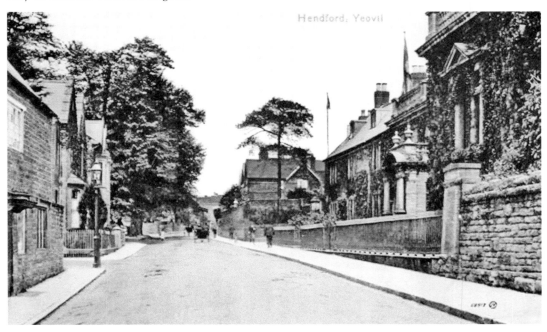

Hendford, Yeovil

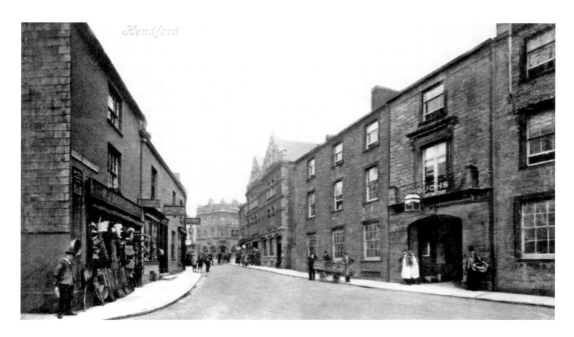

## Hendford

The upper postcard, of around 1910, shows the northern end of Hendford seen from the junction with South Street (off the photo to the right) and Waterloo Lane to the left. All the buildings in this postcard, including the former Three Choughs Hotel on the right, remain today. The lower postcard, of 1905, looks south from Princes Street towards the northern end of Hendford. High Street is off photo to the left. The building at the very centre, with two men standing outside it, was demolished around 1918 for the building of Westminster Street. All other buildings in this image remain today, although the two three-storey buildings to the left are barely recognisable today.

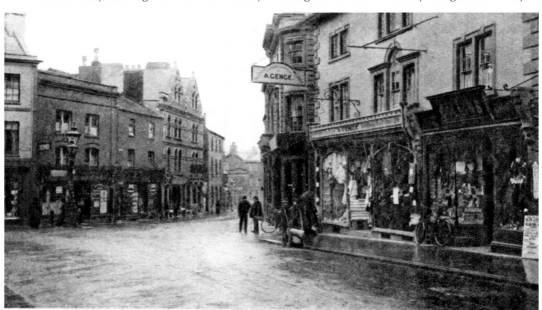

PRINCES STREET AND HENDFORD, YEOVIL

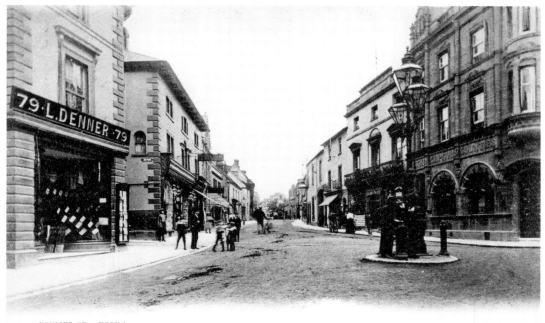

PRINCES ST. YEOVIL.

## Princes Street

The top postcard, of 1905, looks north along Princes Street from the northern end of Hendford. To the left Lynsey Denner's gentlemen's outfitting department, together with Stuckey's Bank, were the buildings demolished for the construction of Westminster Street. The four lads at the centre are standing at the entrance of Porter's Lane, a 10-feet-wide lane that was the precursor to Westminster Street. This postcard was published by the stationer Hallet of Yeovil. The lower postcard, of 1906, was taken a little way into Princes Street by publisher, bookseller and postcard publisher William Beale Collins, whose premises are seen at left.

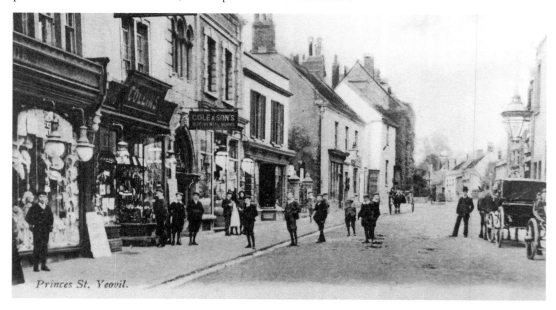

Princes St. Yeovil.

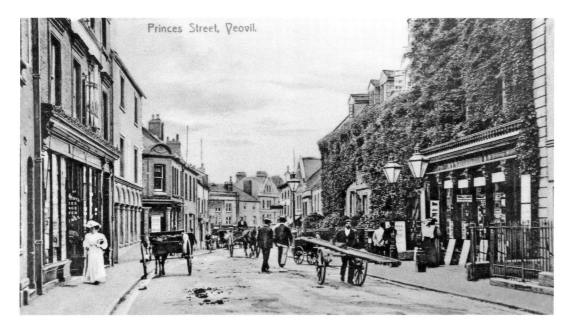

## Princes Street

The upper postcard, of 1908, was published by Ebenezer Whitby, whose bookshop is seen on the right. The view looks south to the junction with High Street and Hendford, with the entrance to Church Street to the left (beyond the horse and cart). Visible in this postcard are the only three streetlights in Princes Street at this time. The lower postcard dates to 1924 and was taken close to the junction with Church Street (seen on the far right). Whitby's bookshop is seen behind the car at centre left. The main difference between these two postcards is that in less than twenty years motor vehicles had largely replaced horse-drawn vehicles.

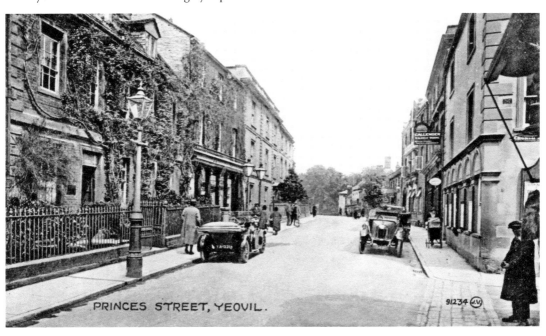

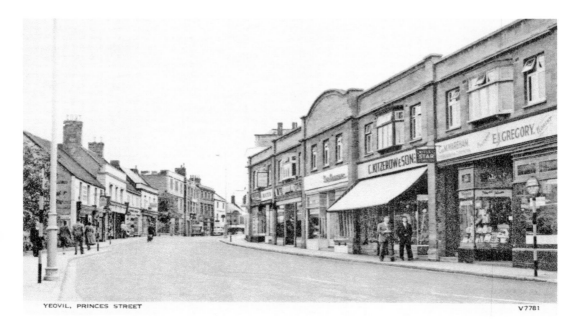

YEOVIL, PRINCES STREET                                          V7781

## Princes Street

We are now at the northern end of Princes Street with the area's oldest buildings, mostly dating to the eighteenth-century, seen to the left. To the right, this parade of buildings was built in 1930 and heralded as Yeovil's new shopping centre. Both of these postcards date to the early 1940s. The lower hand-coloured postcard is the view from Bide's Gardens, showing the junction of Court Ash on the left (with the entrance to the gardens), the northern end of Princes Street in the centre and the southern end of Kingston to the right. The iron railings around Bide's Gardens were removed in the 1940s for the war effort.

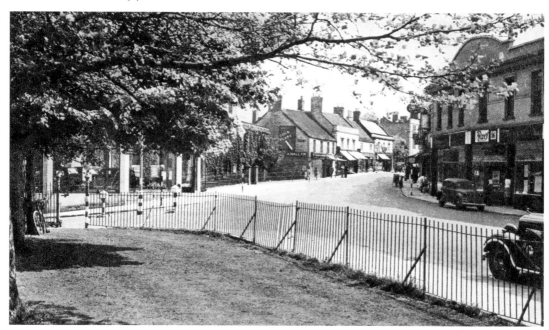

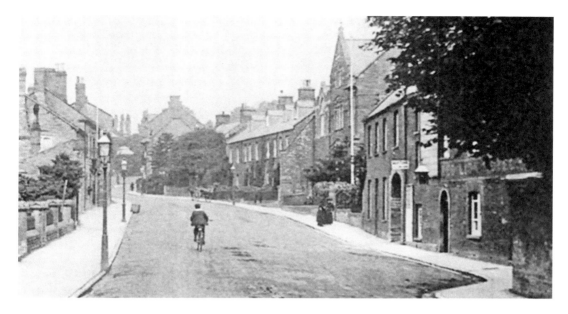

## Kingston

The top postcard dates to around 1910 and looks north along Kingston. The tree on the right marks the north-western corner of Bides Gardens, with the Red Lion public house next to it. The next building along was the County School, founded in 1845 in Clarence Court off Clarence Street, but quickly relocated to this building in Kingston. All buildings in this image were demolished for the widening of Kingston and the building of the new District Hospital. The lower postcard, of 1906, looks south along Kingston from close to the junction with Fiveways. On the left is the relocated toll house that had originally stood at Fiveways.

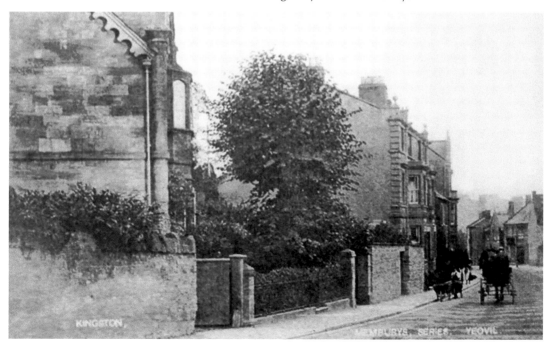

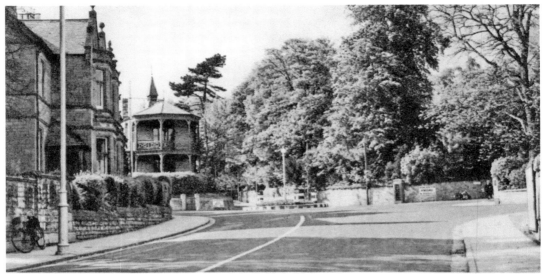

FIVE CROSS ROADS. YEOVIL YEO 108

## Fiveways Roundabout and Hospital

The top postcard, dated 1958 and seen from Kingston, features the Fiveways roundabout before it grew to today's massive proportions. At centre left is glimpsed the Fiveways Hospital, with Preston Road running to its left and Ilchester Road to its right. On the right is seen Mudford Road and the entrance to Higher Kingston. These, together with Kingston, being the five 'ways'. The lower postcard dates to 1908 and is one of many that featured Yeovil's main hospital of the time. The Fiveways Hospital opened in 1872. When the new General Hospital opened in 1923, Fiveways Hospital became the new maternity unit. It was finally demolished in 1969.

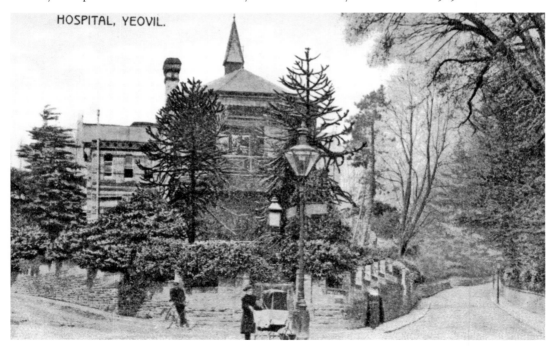

HOSPITAL, YEOVIL.

# CHAPTER 5

# OTHER STREETS

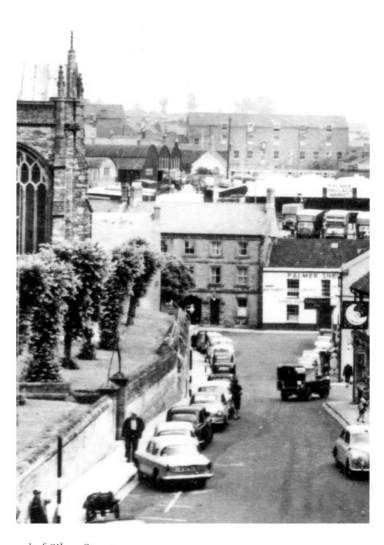

The lower end of Silver Street, *c.* 1959.

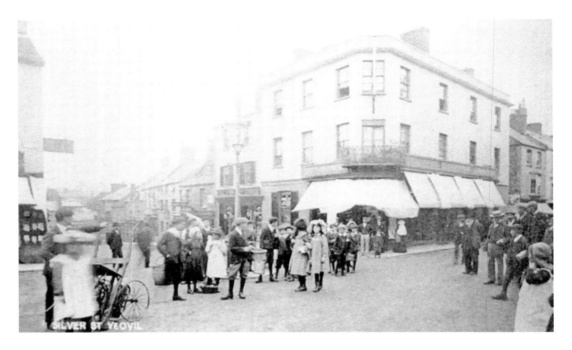

## Silver Street

The early postcard above dates to 1901. Viewed from the Borough, the building in the centre is London House, on the corner of Silver Street to the left and Middle Street to the right. London House was built in 1836 and was occupied by a succession of drapers until its demolition in 1913. The lower postcard, of 1910, looks up Silver Street from outside the Pall Tavern (before the brickwork was rendered over) to the left. It is said that a road called Silver Street often alludes to water, and in Yeovil's case the Rackel stream created a shallow ford across the road, just outside the Pall Tavern.

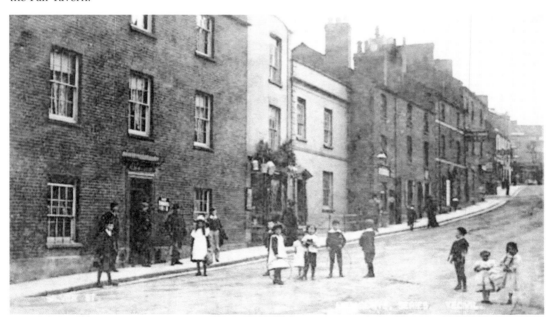

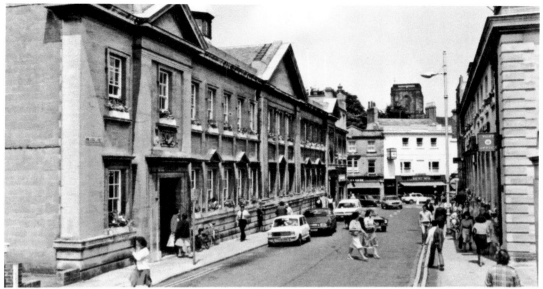

King George Street, Yeovil                                        Y.0105

## King George Street

King George Street, named after George V, was constructed between High Street and South Street in the early 1920s. Initially, only the municipal offices were constructed along the western side of the new King George Street and opened in 1928 (to the left in the upper 1970s postcard). The buildings on the eastern side of King George Street (on the left in the lower postcard of 1935) were not opened until 1932 and were all initially occupied by the post office. Barclays Bank took over part of this building in 1965. Before they were constructed, the site had been the location of the 1927 Yeovil Industries Fair.

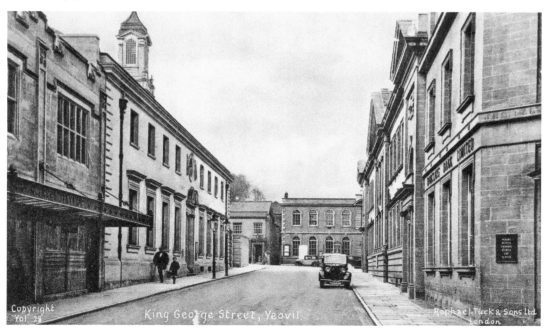

King George Street, Yeovil.

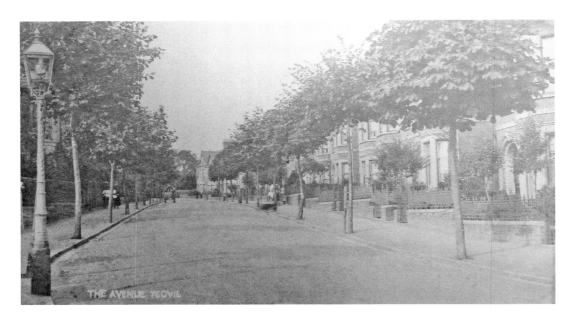

The Avenue and Brunswick Street

The Avenue was originally called Scoles Avenue after Revd A. J. C. Scoles, an architect and the parish priest who designed and built it between 1894 and 1899. At the same time, he built the Church of the Holy Ghost and its presbytery, both on the south-west corner of The Avenue. The postcard above, of around 1905, shows the Avenue with its avenue of young trees looking down towards Reckleford with the church in the distance. The lower 1906 postcard shows Brunswick Street, seen from close to the junction with Hendford. All the properties on the left were demolished in the 1960s for road widening.

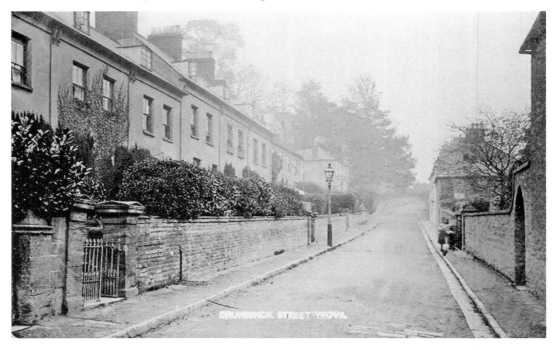

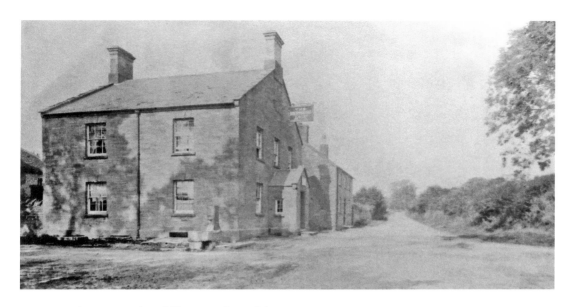

## Dorchester Road and Fiveways Roundabout

Today's Dorchester Road was a subsidiary of the Roman Fosse Way, running from Ilchester (Lindinis) to Dorchester (Durnovaria). It passed through present-day Yeovil before continuing to Dorchester. The 1920s postcard above looks north from the Red House Inn along the Dorchester Road towards Yeovil. Although the records only go back to the 1840s, the Red House was operating long before that. The Red House was probably named as such after Red Mead field, which lay next to it. The lower postcard is from the 1980s and was taken from the greatly enlarged Fiveways roundabout, looking towards Yeovil College (seen in the background).

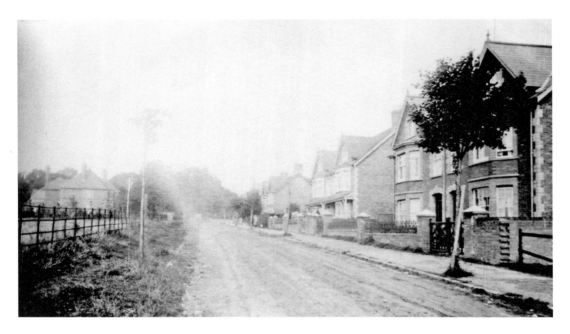

## Grove Avenue and St Michael's Avenue

Grove Avenue was laid out between 1890 and 1900 at which time there were only eight houses on the eastern side. The top postcard of 1905 (looking north) shows a few more houses had been built, but still only along the eastern side. At this time, all were technically in Preston Plucknett since the parish boundary, between Yeovil and Preston Plucknett, ran along the end of their rear gardens. The lower postcard of St Michael's Avenue dates to around 1905. It was originally called Brickyard Lane because of brickyards at either end. It was renamed shortly after St Michael's Church was consecrated in 1897.

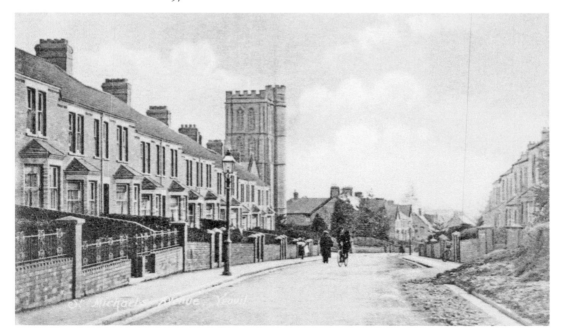

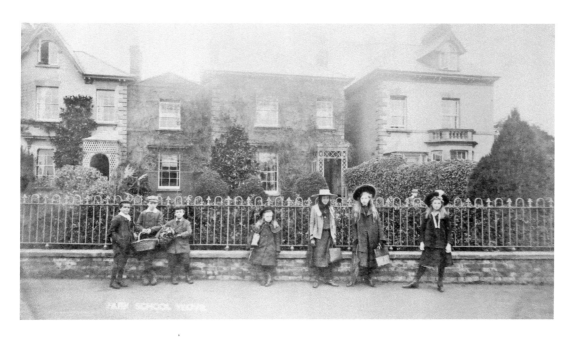

## Park Road

What is now Park Road was originally a narrow lane called Pitney Lane, after the name of the manor, Kingston Pitney, whose boundary ran along its length. Pitney Lane connected Princes Street with Clarence Street which, at this time, terminated at its junction with Pitney Lane. Beyond Clarence Street, Park Road was built in the early 1860s. Above, is a postcard showing Park Road, posted in 1908. The building at the centre was occupied by the Park School from at least 1869. The lower postcard is also Park Road, looking east to the town centre, and dates to around 1914. The houses in this image were all demolished when Queensway was built in the late 1970s.

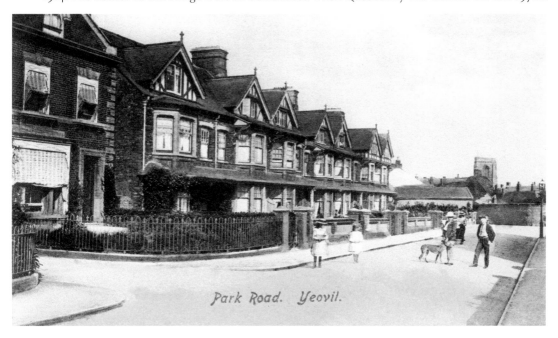

Park Road. Yeovil.

## Preston Road

Above is a 1910 postcard. The view, seen from Grove Avenue, looks towards the eastern end of Preston Road. The man is seen standing outside the gates of Yeovil Cemetery (consecrated in 1860) with the cemetery's Lodge House on the left. This scene is almost unchanged today. The lower postcard dates to 1954 and is of the western end of Preston Road. In the distance is seen the tower of St James' Church. The majority of the cottages in Preston Plucknett, on either side of Preston Road, were demolished for road widening and straightening in the 1960s.

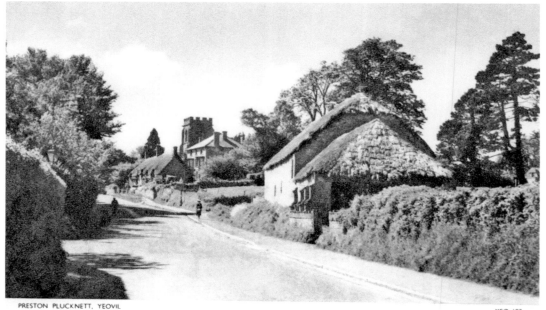

PRESTON PLUCKNETT, YEOVIL

YEO 107

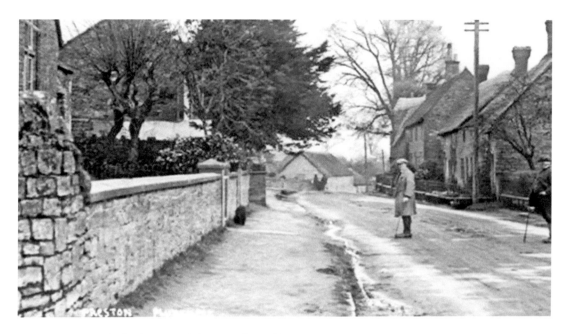

Preston and Plucknett and Preston Great Farm

Although mostly incorporated within Yeovil in 1928 (small parts being absorbed by the adjacent parishes of Brympton and West Coker), Preston Plucknett retained a rural village charm with its many thatched roadside cottages. The upper postcard dates to the 1930s and looks east. Preston Great Farm, commonly known as Abbey Farm and seen in the lower postcard of 1910, was the manor house of Preston Plucknett. The house and barn (the longest in Somerset) are thought to have been built by John Stourton during the reign of Henry V (1413–22). It was never an ecclesiastical building but the mistake was made by Lady Georgiana Fane when she inherited the property in 1841.

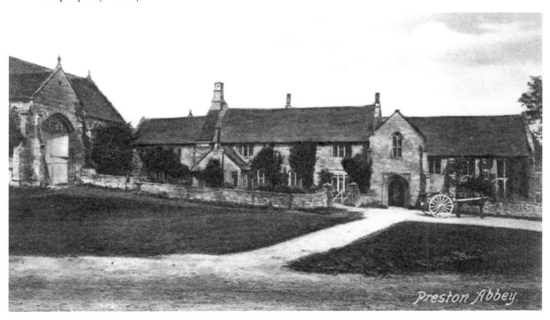

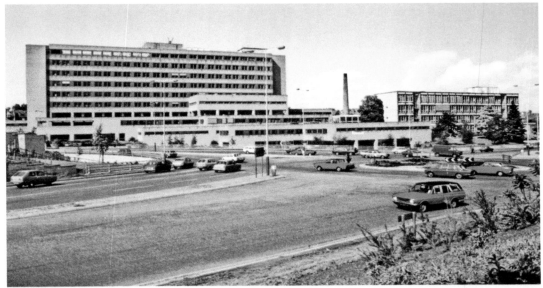

The Hospital, Yeovil                                                                Y.0104

## Queensway and Reckleford

Ostensibly featuring Yeovil District Hospital, the upper postcard was issued to celebrate the newly opened Queensway. This new dual carriageway, opened in the Queen's Silver Jubilee year of 1977, takes up the lower half of the image. It was laid out as Stage Two of a ring road for Yeovil (albeit passing through the town rather than around it). To the left, Kingston passes the hospital, while to the right is seen the western end of Reckleford. The lower 1969 postcard shows the eastern end of Reckleford at its junction with Eastland Road (on the left) and Wyndham Street (on the right). The grass area of the foreground had originally been the site of glove workers' cottages.

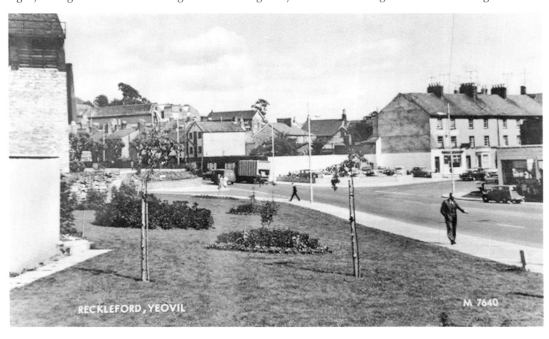

RECKLEFORD, YEOVIL                                                      M 7640

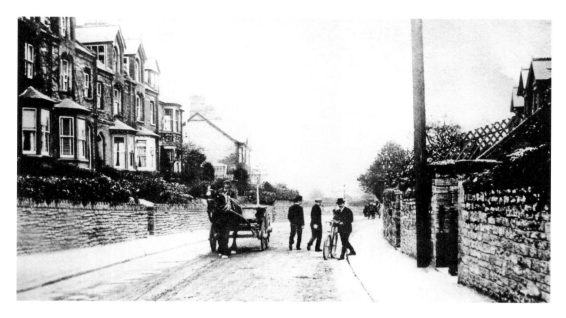

## Sherborne Road and South Street

The upper postcard, of 1904, depicts Sherborne Road looking east towards Lyde Road. Originally called London Road, large houses began springing up both sides of the road from the 1870s onwards since the area was considered more salubrious, and healthier, than the town centre. The lower postcard was published in 1914. It shows the eastern end of South Street as it joins the Triangle. South Street is flanked by Albany Ward's Palace of Varieties (opened in February 1913 and demolished in 1934) to the left, and the Yeovil & District Co-operative Society's new retail store and offices to the right, which opened in 1910.

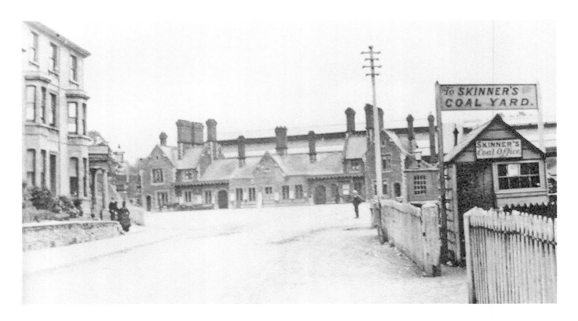

## Station Road and St Michael's Avenue Area

The upper postcard, of 1910, looks down Station Road (now Old Station Road) to Yeovil Town railway station with the corner of the Alexandra Hotel to the left and Skinner's coal yard to the right. William Skinner had originally worked on the railways, rising to inspector and kept a beerhouse in Middle Street. By 1871 he was recorded as a coal merchant and cannily located his coal yard in Station Road, which was adjacent to the railway goods yard. The lower postcard dates to 1934 and is an aerial view of St Michael's Avenue (left), Rosebery Avenue (top), St Michael's Road (bottom), with (from left to right) Glenville Road, Percy Road and Alexandra Road, all surrounded by open fields.

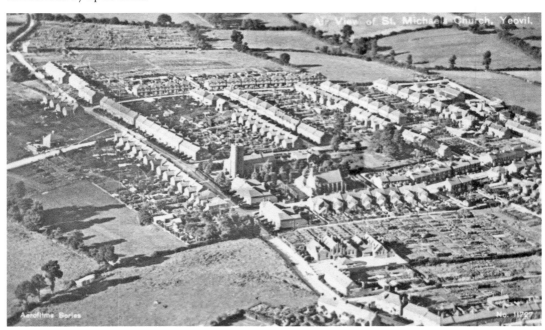

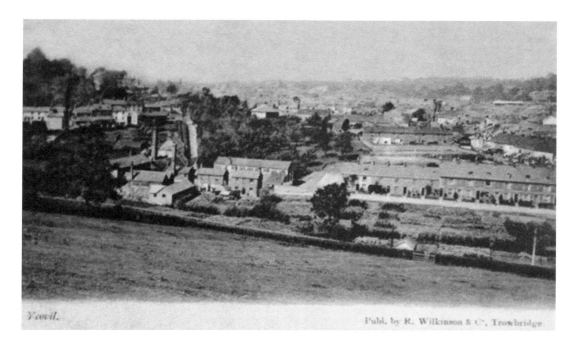

Yeovil.

Publ. by R. Wilkinson & Co., Trowbridge

## Summerhouse Terrace and Talbot Street

Above is one of the earliest postcards in this book, dating to around 1899 or even earlier. It is a view from Summerhouse Hill. In the foreground, the allotments were later replaced by the large Blake & Fox glove factory but today is housing. Summerhouse Terrace is seen at centre right, but Talbot Street has yet to be built behind it. The large group of trees in the centre are the orchards of Park Street House and to its immediate left is Mill Lane – with no houses either side. The lower postcard, photographed around 1900 but posted in 1905, shows the new houses in Talbot Street.

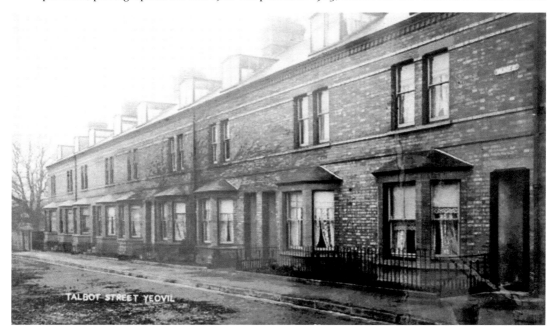

TALBOT STREET YEOVIL

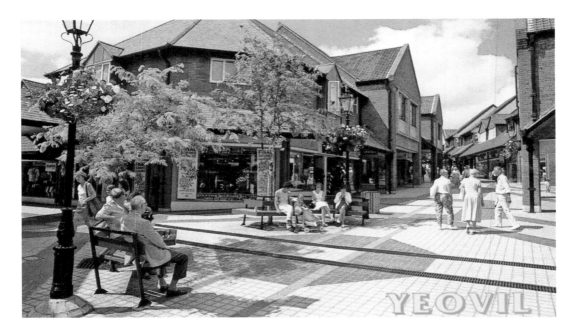

## Vicarage Walk and Victoria Road

Building the £21 million (or £14 million, depending on your source) Quedam shopping precinct during the early 1980s was the largest construction project ever to be undertaken in Yeovil. Indeed, it is claimed that it was the second largest development of its kind in the country at that time. The upper postcard, dating to the mid- to late-1980s, proudly shows the new Vicarage Walk as seen from Ivel Square. The lower postcard, of 1904, shows an early branch store of the Yeovil & District Co-operative Society on the corner of Victoria Road. The store moved along to the corner of Cromwell Street almost as soon as the latter had been built, which was around 1905.

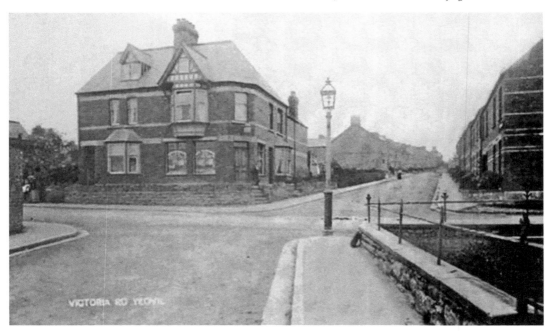

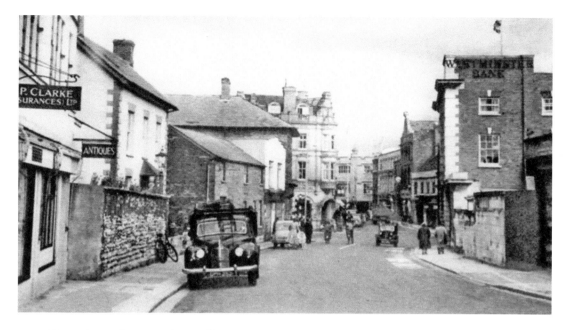

## Westminster Street and Wyndham Street

Westminster Street was originally a very narrow lane, little more than an alleyway, leading to Huish. Stuckey's Bank had been built in Hendford in 1835 and the present Westminster Bank replaced it in 1919, albeit slightly further along the road. In 1924 the lane was finally widened to its present width and renamed Westminster Street after the bank. The upper postcard, of the 1950s, looks along Westminster Street to Hendford and High Street. The lower postcard, of 1905, looks towards Wyndham Street, with the Elephant & Castle at left. The following year the new *Western Gazette* office would be built where the stone wall is at bottom right.

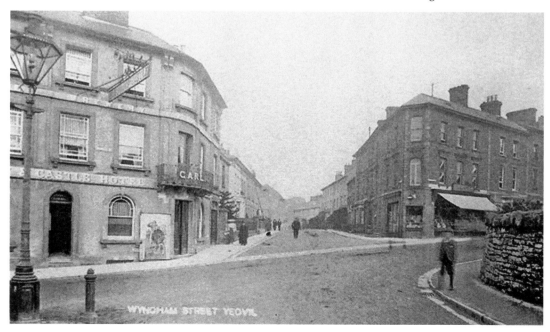

# CHAPTER 6

# HOUSES, LARGE AND SMALL

Salisbury Terrace, Reckleford, *c.* 1920. Note the garden railings, once common throughout Yeovil.

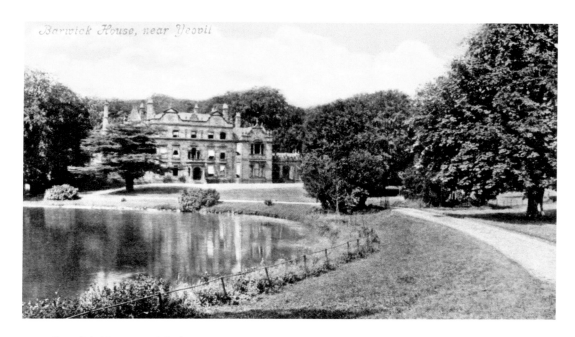

Barwick House, near Yeovil

## Barwick House and Park

Barwick House appears to have been built around 1770 by John and Grace Newman, whose relations owned neighbouring Newton Surmaville. The estate had originally formed part of the property of Syon Abbey, Lords of Yeovil, and passed through various hands after the Dissolution of the Monasteries in the 1530s. Barwick House was used variously as a prisoner of war camp and a US army base during the Second World War. During the 1960s until the 1980s it was a reform school before falling into disrepair. The upper postcard, of 1912, shows Barwick House fronted by its lake while the lower card, of 1905, shows the house in its wider setting.

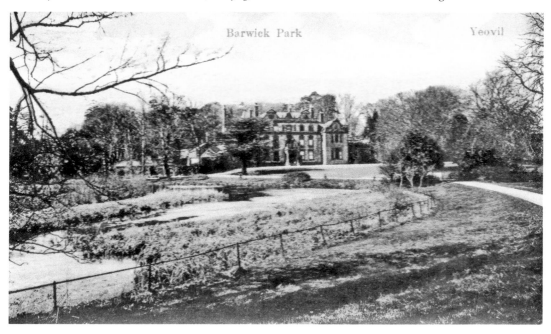

Barwick Park          Yeovil

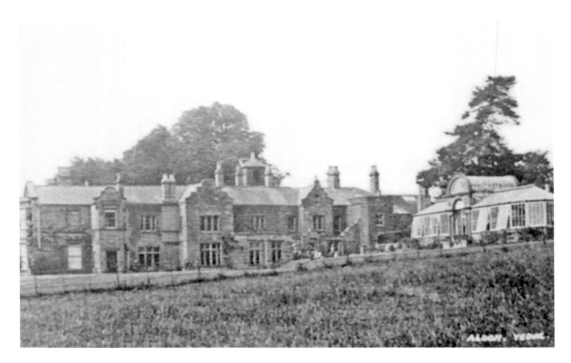

## Aldon and Braggchruch

Set within extensive parkland and originally a working farm, Aldon became the home of Yeovil banker and solicitor John Batten the elder, who purchased the estate in 1829. Today's house is a mid-nineteenth century-country house built of Ham stone ashlar with a Welsh slate roof partly hidden behind parapets. The upper postcard dates to 1910, while the lower postcard, of Braggchurch, dates to the 1920s. The first mention of Bragg Church is in a lease of 1670 and in 1791 it was noted 'anciently a church or chapel' existed here. The large house was built near the site of the chapel in 1892, taking the name Braggchurch.

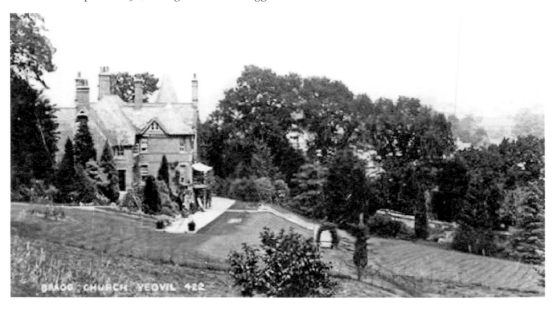

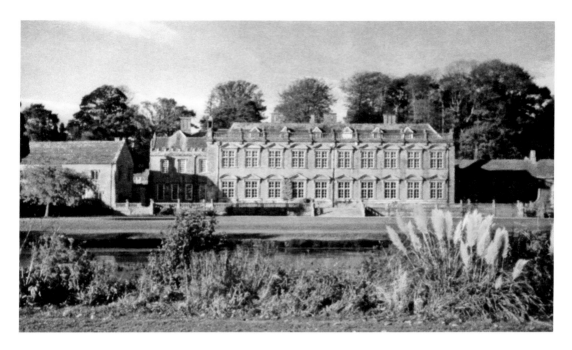

## Brympton House

Both postcards on this page, of the 1980s, are of Brympton d'Evercy, also known as Brympton House. The building was begun by the d'Evercy family around 1220, being slowly, yet continuously, expanded until the eighteenth century. In 1927 the magazine *Country Life* published a set of three articles on the house in which Brympton d'Evercy was described as 'the most incomparable house in Britain, the one which created the greatest impression and summarises so exquisitely English country life qualities'. The house is part of a complex consisting of the mansion, the parish church, a building known as the Priest House, stables and other outbuildings.

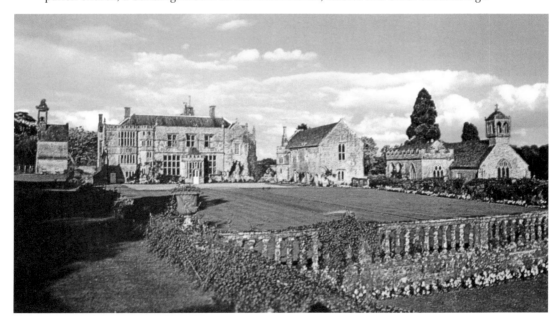

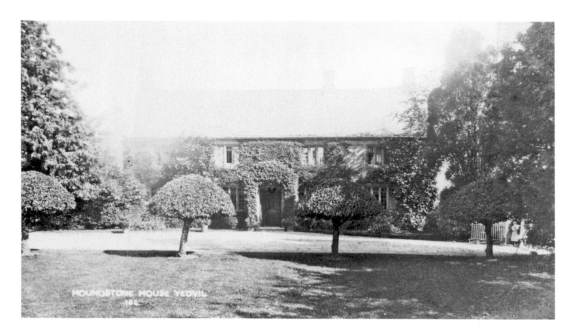

## Houndstone House and Little Lyde Farm

The upper postcard, of 1905, depicts Grade II listed Houndstone House. This is a seventeenth- and eighteenth-century detached house of cut and squared Ham stone with ashlar dressings under a Welsh slate roof. Little Lyde Farm, seen in the lower postcard of around 1920, was originally a medieval farmstead located approximately where the open space is today on the north side of Lyde Road, and bounded by Sandringham Road, Balmoral Road and Howard Road. It is believed to have been demolished in the 1950s.

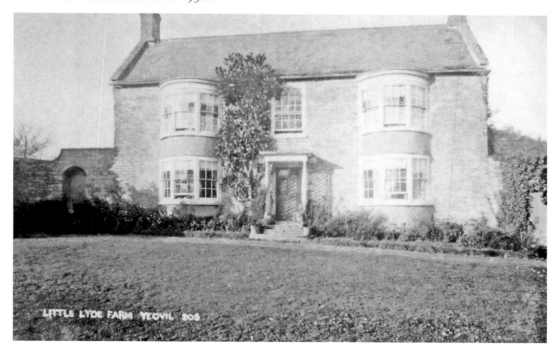

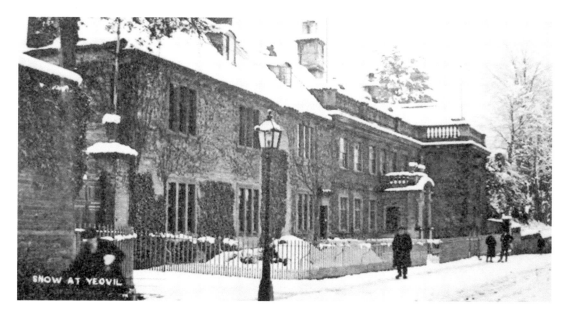

SNOW AT YEOVIL

## Hendford Manor

Both postcards on this page are of Hendford Manor, halfway along the eastern side of Hendford. The upper postcard shows the Hendford elevation photographed during the 'Great Snow' of 1908 while the lower card, of 1905, depicts the rear gardens, now the site of the Octagon Theatre. Hendford House was originally built around 1740 for Revd James Hooper, a Yeovil solicitor. It is a fine town house of Ham stone ashlar with a Welsh slate roof. Around 1820 two flanking wings with Venetian windows were added, and linked together some twenty years later by extra rooms at the rear, forming a small central courtyard.

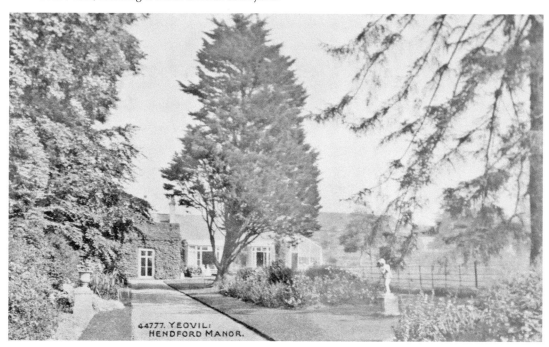

44777. YEOVIL: HENDFORD MANOR.

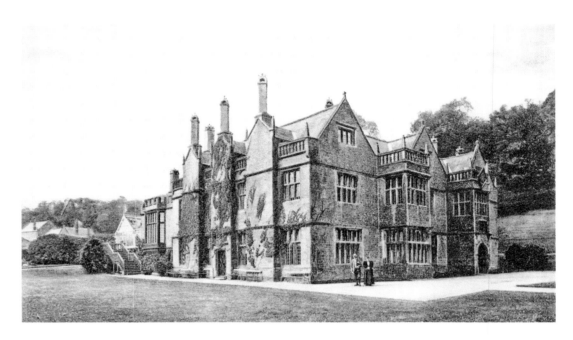

## Newton House

In 1608 a wealthy mercer, Robert Harbin (1526–1621), purchased the estate, to the south-east of the town of Yeovil, known as Newton Surmaville, which was named after a French family, the de Salmonvilles, who first built a medieval house on the site where the current house now stands. Robert Harbin and his eldest son, John (1560–1638), commissioned the building of a new grand country house at Newton, which was completed around 1612. The house remained in the Harbin family home for 399 years, until 2007, through more than ten successive generations. The upper postcard dates to the 1920s. The photograph for the lower photograph was taken around 1897 and used for postcards from 1898 until the 1960s.

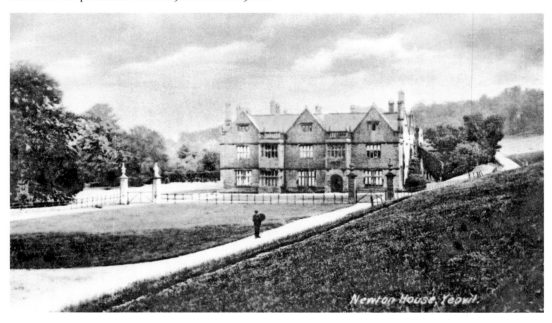

# CHAPTER 7
# PARKS AND OPEN SPACES

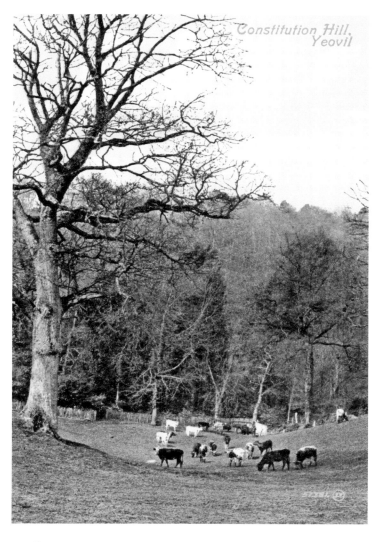

Constitution Hill, 1906. It is still a lovely, quiet place to walk.

## Bide's Gardens

The four postcards in these two pages all feature Bide's Gardens. The postcard at the top left views the entrance to the gardens with Princes Street beyond (1942). Of note is the captured First World War German howitzer given to the borough council by the War Office Trophies Committee and originally sited on a concrete plinth in the Triangle. The howitzer was moved to Bide's Gardens in 1922 where it remained until it was taken away after the Second World War. Lower left is the view south-east to St John's Church (1926), top right is the new General Hospital (1922–73) seen from Bides Gardens (1930) and lower right is the shelter close to the Princes Street entrance (1957).

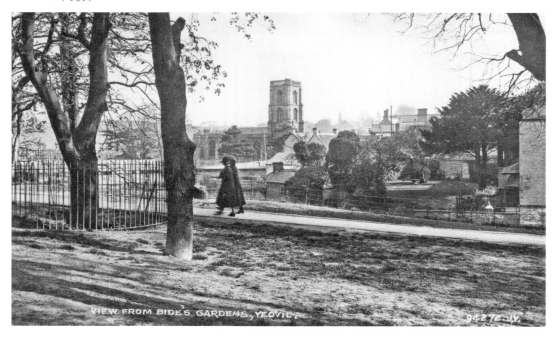

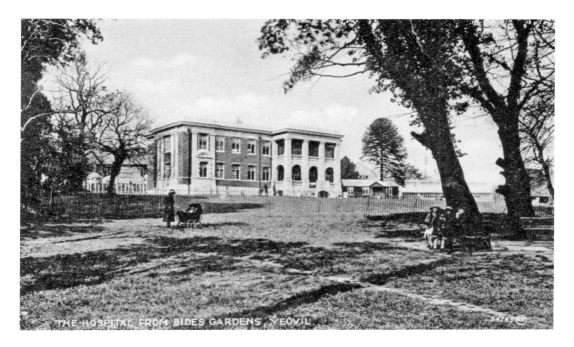

THE HOSPITAL FROM BIDES GARDENS, YEOVIL.

## Bide's Gardens

Bide's Gardens were donated to the town by Thomas William Dampier-Bide (1844–1916), the son of glove manufacturer Thomas Dampier (1801–76). He lived in Kingston Manor House and on his death in 1916 bequeathed to the town a large part of the grounds of Kingston Manor House (lying between Higher Kingston, Court Ash, Court Ash Terrace, Kingston and Red Lion Lane). The new General Hospital opened on 16 December 1922 but was officially opened on 19 July 1923 by HRH the Prince of Wales, later Edward VIII. Yeovil lost Bide's Gardens in the 1970s with the building of the Yeovil District Hospital and the widening of both Reckleford and Kingston.

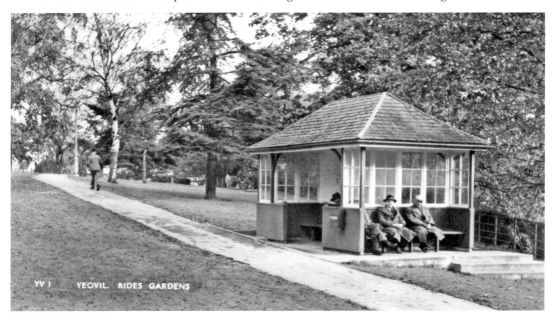

YV 1    YEOVIL. BIDES GARDENS

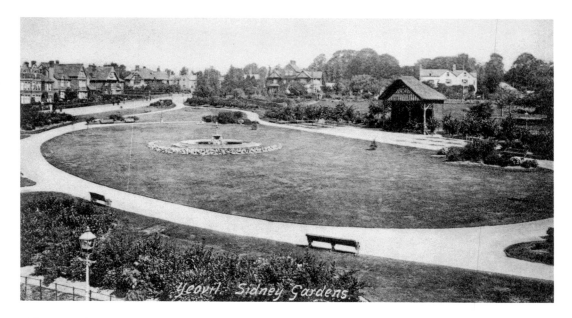

## Sidney Gardens

The next eight postcards all feature Sidney Gardens. The garden, a three-acre triangle of open space in Ram Park, was presented to the town by Alderman Sidney Watts when he was mayor, to commemorate the 1897 Diamond Jubilee of Queen Victoria. The upper postcard is one of the earliest postcards in this book: the photograph was taken in 1898 and the postcard, published by Whitby of Princes Street, dates to 1899 or 1900. Very little planting had been done by this time. The lower postcard, also looking west, is one in a popular Edwardian series featuring the vignette format and looks across the gardens to the west. It was posted in 1906.

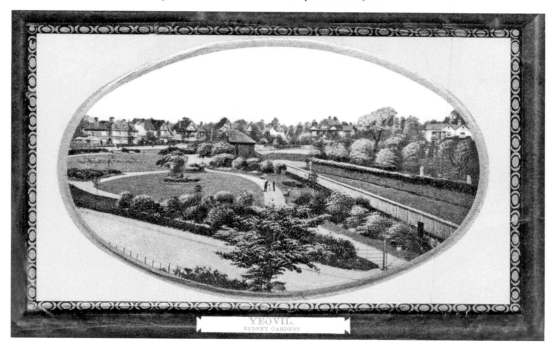

YEOVIL.
SYDNEY GARDENS

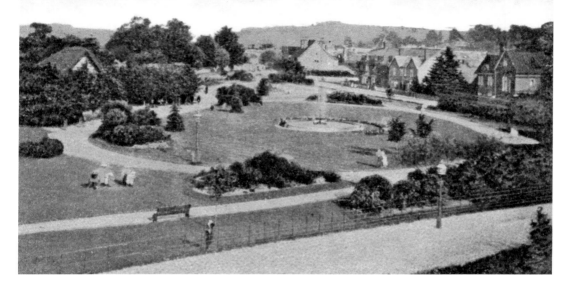

SYDNEY GARDENS, YEOVIL.

### Sidney Gardens

The gardens were created at a cost of £760 and Mr Watts graciously named the gardens after himself. However, as he was away representing Yeovil at the jubilee celebrations in London, the ceremony was carried out by his two daughters, Ada and Mildred. It was estimated that over 5,000 people witnessed the ceremony as Ada handed the deeds of the land to the deputy mayor, William Cox. The upper postcard looks east from one of the houses in Grove Avenue and is dated 1908. The lower postcard, one of a series of some twelve designs, features the paths weaving throughout the gardens between colourful flower beds. This postcard dates to 1916.

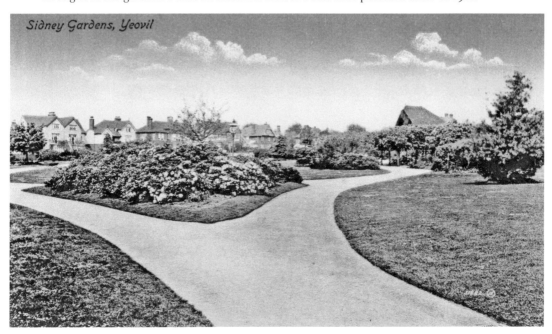

Sidney Gardens, Yeovil

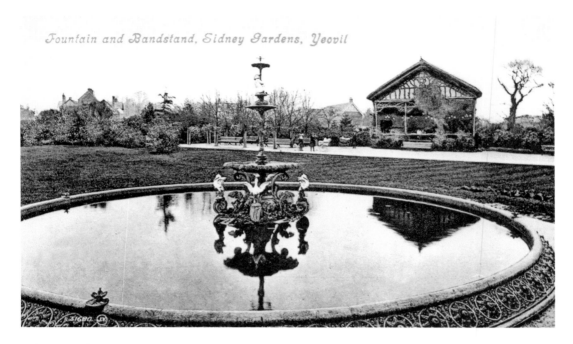

*Fountain and Bandstand, Sidney Gardens, Yeovil*

## Sidney Gardens Fountain

The fountain, which hasn't seen water for many years, was presented to the town by John Farley on 24 May 1899 to commemorate Queen Victoria's eightieth birthday. It was restored in 1991 but when civic chiefs and private sponsors gathered for the official switching on ceremony it was discovered that a pump had been stolen and the stem damaged. It has been dry ever since. The upper postcard dates to 1907. The lower is from Dennis & Son's Photoblue series of the late 1950s and features both the fountain and the bandstand.

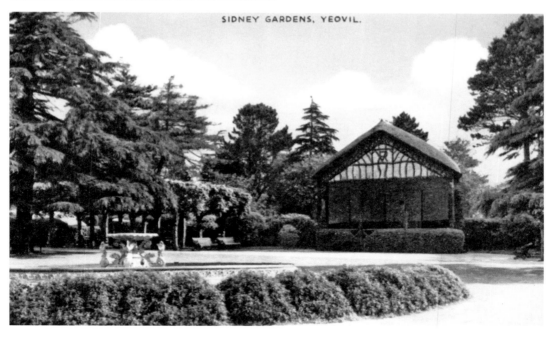

SIDNEY GARDENS, YEOVIL.

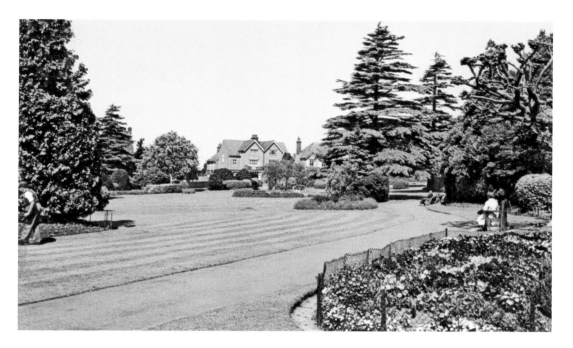

## Sidney Gardens and Bandstand

The upper postcard was sent in 1964 and shows how the trees and shrubs had matured over the previous sixty years. The lower postcard, of 1971, features the bandstand that was destroyed by vandals in 1972, never to be replaced. Ironmonger James Bazeley Petter had presented the bandstand to the town at the time of Queen Victoria's 1887 jubilee. Constructed of timber, all the rustic work was cut from laurel that grew at Ninesprings. Note that, even at this time, the fountain was being used as a raised flower bed. A sundial on a stone plinth was installed in the gardens in 1912 commemorating the gift of the gardens to the town. It was almost immediately vandalised.

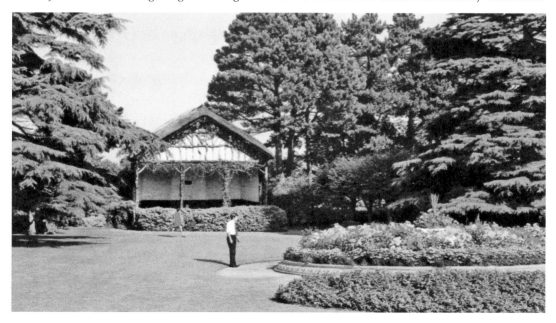

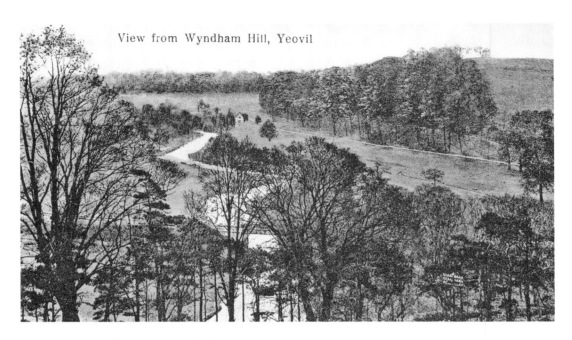

View from Wyndham Hill, Yeovil

Newton Surmaville House and Park

This page shows two postcards that look south from Wyndham Hill, on the southern edge of the town, and feature Newton Surmaville House and its parkland nestling in the meandering Yeo Valley. In both images, the top right quadrant is dominated by Summerhouse Hill, which is surmounted by the Summer House. The flanks of the hill are covered by Newton Woods. The upper postcard dates to the 1920s, while the lower card was posted in 1906. The summit of Wyndham Hill offers spectacular views of the town and surrounding countryside. Lime trees were planted on the summit to celebrate Queen Victoria's Silver Jubilee in 1862, although there were considerably more than the present four trees.

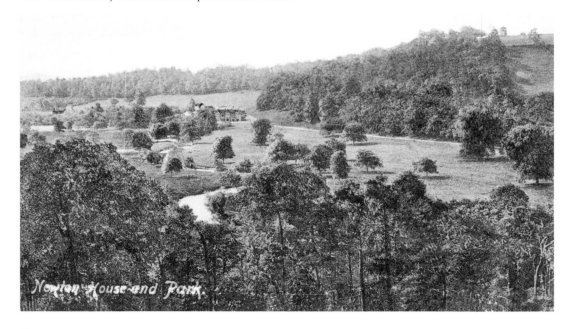

Newton House and Park.

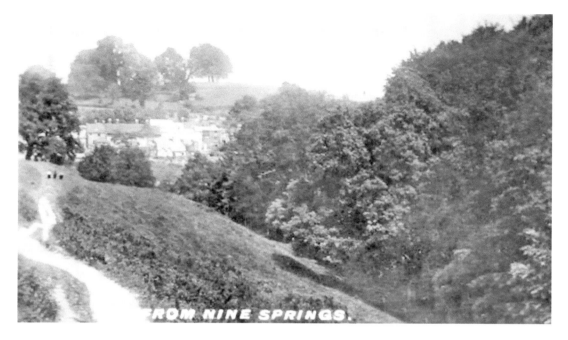

ROM NINE SPRINGS.

Ninesprings

The following ten postcards are all various aspects of Ninesprings – the wonderful broad-leaved woodland valley of around 20 acres. Lying on the south-east edge of Yeovil, its nine springs supply water to small streams and ponds. Ninesprings was acquired by the district council in the 1970s and has now, having been restored, been incorporated into the 127-acre Yeovil Country Park. The upper postcard of the 1920s looks back from the valley towards Penn Hill. The lower postcard dates to 1936 and shows one of the rustic bridges spanning the small stream.

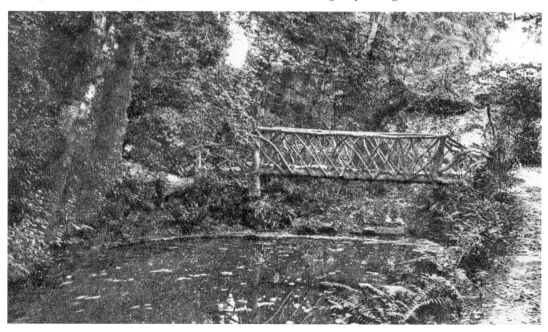

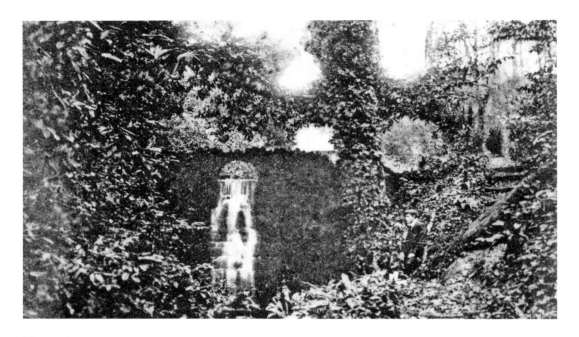

## Ninesprings

Ninesprings was developed as an ornamental park for the Aldon estate during the early nineteenth century and included walks, bridges, grottoes, nine springs and lakes. Until the mid-twentieth century, the public only had access by tickets obtainable from the owner, Colonel H. B. Batten, the town clerk. Today the valley is well maintained and is a popular attraction. The very early upper postcard, sent in 1900, features the cascade with the footpath to the right. The lower postcard, of 1902, shows the first glimpse of the cottage.

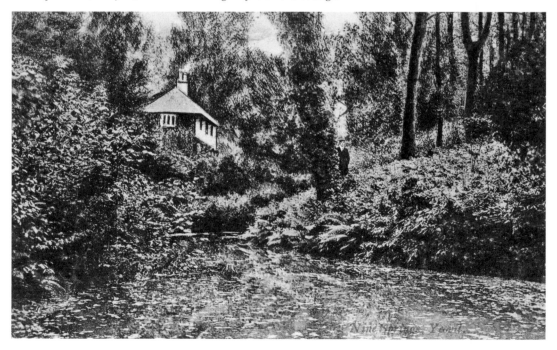

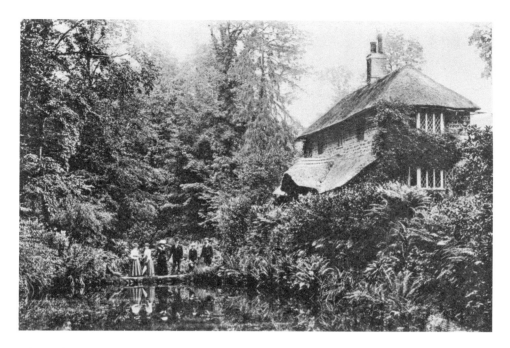

## Ninesprings

The upper postcard, of 1904, is unusual in that it shows the Batten family in the lower left who owned Ninesprings and the cottage at the time. The lower postcard, by William Beale Collins of Princes Street, dates to 1903. The once picturesque thatched cottage that appears in so many photographs of Ninesprings served cream teas for many years. Indeed, after St John's Church, the cottage at Ninesprings was the most popular subject for Yeovil postcards. The cottage suffered neglect during the Second World War and was allowed to quietly fall into ruin. It was finally demolished in 1973, although the foundations are still visible.

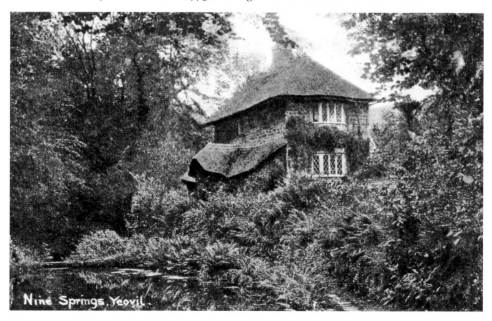

Nine Springs. Yeovil.

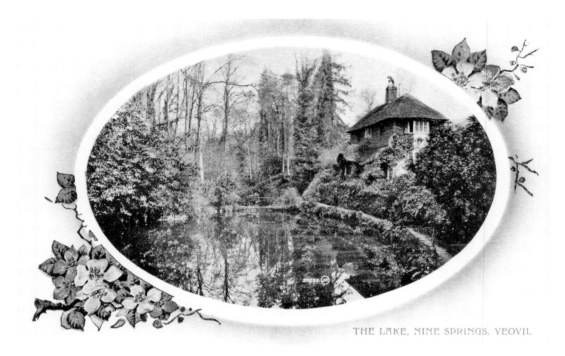

THE LAKE, NINE SPRINGS. YEOVIL

## Ninespings Lake and 'Great Snow'

On 19 August 1904, forty-two-year-old wheelchair-bound Louisa Harris wrote of her first visit to Ninesprings: 'It is a veritable paradise, what with its magnificent growth of woods, its wealth of ferns, cascades, trickling springs, still pools, driplets, placid flowing stream, and its numerous many paths and other beauties innumerable.' Above is a vignette postcard with a lovely floral decorative surround of the type that was so popular in the Edwardian period. The cleverly hand-coloured postcard, of 1910, features the lake in front of the cottage. The spectacular lower postcard features the Ninesprings cottage and its lake during the 'Great Snow' of 1908.

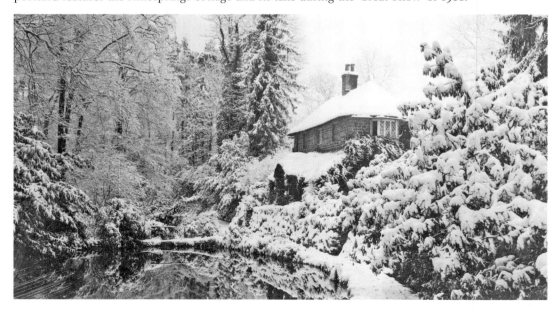

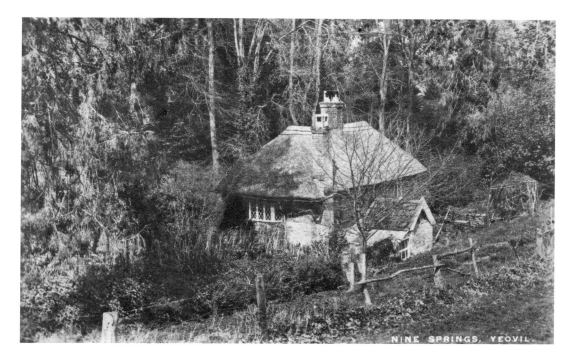

## Ninesprings Cottage

On her second visit to Ninesprings, in 1906, Louisa Harris wrote in her diary of her visit to take tea at the cottage: 'Tea was spread in a picturesque rustic porch looking down on a still pool bordered by woods, magnificent ferns and all manner of beautiful growths.' The upper postcard, sent in 1931, is an unusual view of the rear of the Ninesprings cottage, while the lower postcard featuring the 'picturesque rustic porch' at the front of the cottage dates to 1939.

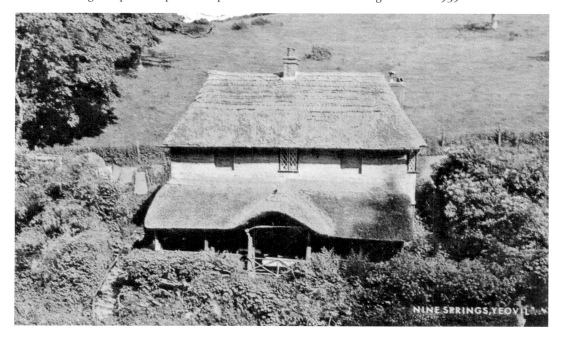

# CHAPTER 8
# GENERAL VIEWS & MULTIVIEWS

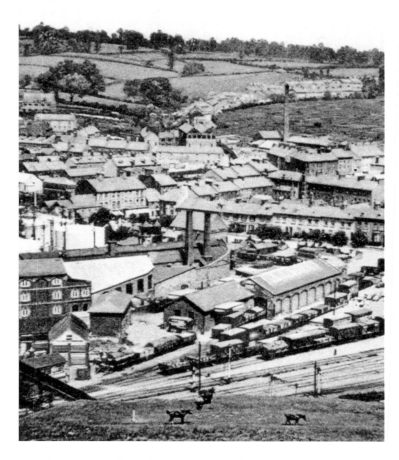

View to Yeovil Town station from Summerhouse Hill, 1905.

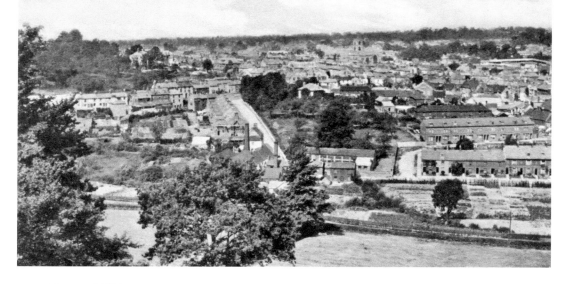

*Yeovil from Summer House Hill*

## View to Mill Lane

Summerhouse Hill, to the immediate south of the town, is the obvious vantage point from which to take panoramic vistas of Yeovil. Over three dozen different postcards depicting views of the town from the summit of the hill were produced during the Edwardian era. The upper postcard, of 1904, shows Mill Lane left of centre with the large orchards of South Street House in the centre. At centre right is Summerhouse Terrace (note the allotments) in front of Talbot Street. By the time of the lower postcard of 1909, the orchards are gone and Mill Lane has houses on both sides.

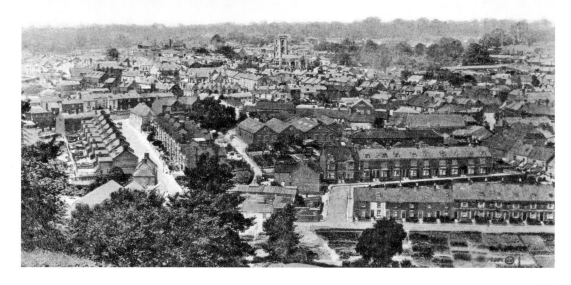

*Yeovil from Summerhouse Hill*

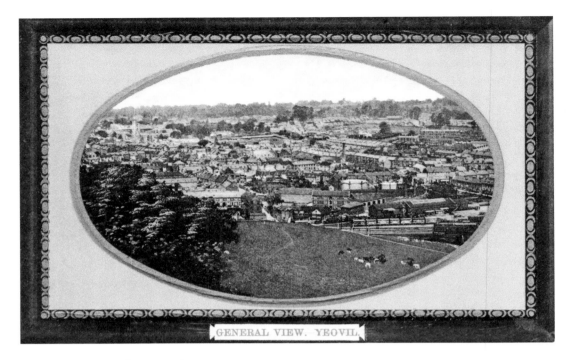

GENERAL VIEW. YEOVIL.

### View from Summerhouse Hill

The upper postcard is one of a series of a dozen or so Yeovil postcards using this Edwardian vignette and surround, dating to 1909. The view is slightly east of the previous two postcards and features the Yeovil Town railway station in the bottom right. Just visible above the station yard are the two gasholders of the town gasworks, which was entered off Middle Street via today's St Margaret's Hospice shop (the building was the original gasworks offices). The lower card, of around 1918, is again almost the same as the previous three cards, except here the allotments running alongside Summerhouse Terrace have been replaced by glove factories.

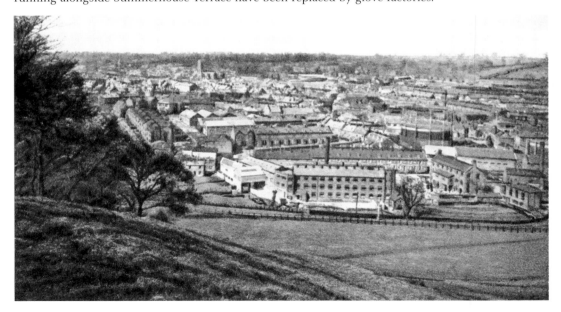

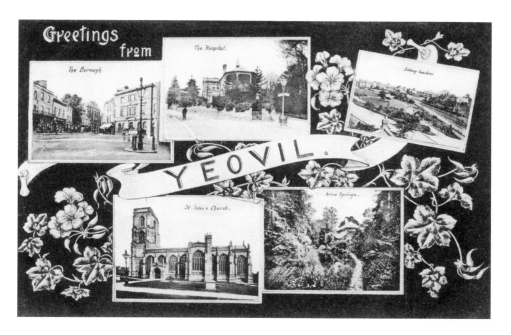

## Yeovil Multiviews

It was soon realised by the postcard publishers that you could offer more views for your money with a multiview postcard – an early sales gimmick. The upper postcard is a very early example that was posted in 1905. The lower postcard, of 1918, is from a series of about a dozen postcards of the same period published by Yeovil stationer H. T. Balls. The series featured the town's crest in the centre of various views of the town. There were usually four views with a central crest in landscape orientation, as here, or two views and a crest in portrait format. Multiview cards without a crest could often feature ten or twelve views per card.

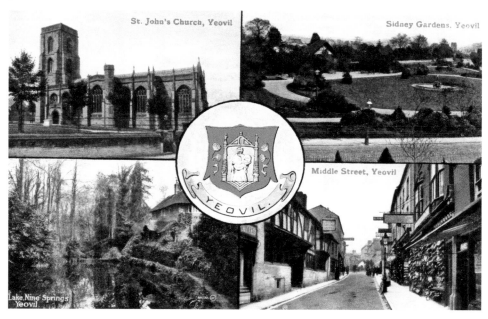

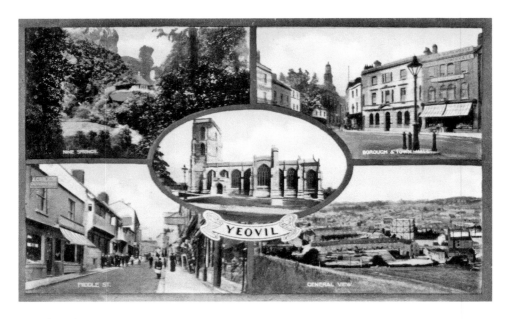

## Yeovil Multiviews

During the 1920s a series of about a dozen multiview cards of Yeovil were produced, in both landscape and portrait formats, with five, six or seven views against a dark green background. Several were published by Jackson & Sons of Grimsby, but the style was copied almost exactly by H. T. Balls of the Triangle. The upper card is an example and was posted in 1922. The lower postcard dates to 1985 and features, in the top right, the newly opened Quedam shopping centre. Sadly, today only one postcard of Yeovil is available in the shops. It is a multiview.

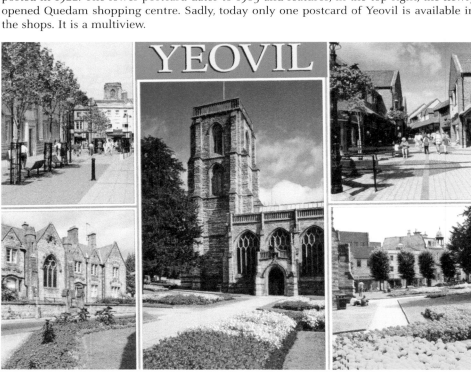

# CHAPTER 9
# NOVELTY CARDS

A novelty card, the flap of which is lifted to reveal eleven tiny folding views (seen on the right).

Pack up your Bag
And come to    YEOVIL

It's Full of Lovely Views!

1458

**Novelty Suitcase and Dog**

There were several types of novelty postcards, but perhaps the most popular type contained a 'hidden' strip of small views, invariably monochrome, that could be revealed by lifting a flap on the front of the card – as in the novelty card featuring a kitten on the previous page and the two examples on this page. At least a dozen of this type of novelty card is known for Yeovil, all dating to around 1912. The images and slogans include a train 'Arriving at Yeovil', roses 'Thinking of you at Yeovil', a cartoon dog 'Always be merry and bright at Yeovil', a black kitten in a boot 'Good luck in a shoe and all for you from Yeovil', and so on.

Taking Things
Quietly at    YEOVIL

2087

## Large Letter and Giant Postcards

The upper card is from Milton's Glazette series and is, technically, called a 'large letter' type because it features the name of the town with each letter containing small views. In this example, the letters contain a total of nineteen views as well as the town crest and a pair of leather gloves representing the town's staple trade at this time – 1907. The lower card is a 'giant' postcard produced to celebrate the coronation of Elizabeth II in 1953. Standard postcard measurements are 148 mm by 105 mm or 5.8 inches by 4.1 inches, but this card measures 214 mm by 150 mm or 8¼ inches by 6 inches.

# ACKNOWLEDGEMENTS

Many thanks to Mike Monk for proofreading not only this book but also my 2,100-plus page website, www.yeovilhistory.info, which details in much greater depth every subject in this book. All the photographs in this book are from my collection of old Yeovil postcards. Every attempt has been made to seek permission for copyright material used in this book. However, if we have inadvertently used copyright material without permission or acknowledgement we apologise and we will make the necessary correction at the first opportunity.

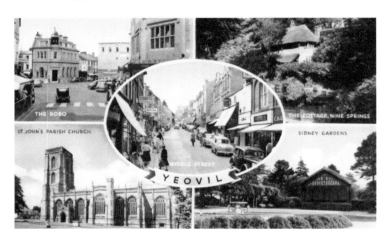

A multiview card from Dennis & Sons' 'Photoblue' series of the late 1950s.

# ABOUT THE AUTHOR

Local historian Bob Osborn is the author of several books on an eclectic range of subjects. His local history titles include *A–Z of Yeovil*, *Secret Yeovil*, *Yeovil in 50 Buildings*, *Now That's What I Call Yeovil* and *Yeovil from Old Photographs*. After a career in architecture, admin management, web design and management and, latterly, as a learning centre manager and Yeovil College lecturer teaching IT, he is now retired. Bob moved from North London to Yeovil, Somerset, in 1973 and since retiring works almost daily researching and compiling his ever-growing website 'The A-to-Z of Yeovil's History', which currently has over 10,000 images. Bob has four grown-up children and lives in Yeovil with his wife Carolyn and Alice the cat.